1.

Photographs of Moholy-Nagy

from the collection of William Larson

Edited by Leland D. Rice and David W. Steadman

The Galleries of the Claremont Colleges Pomona College Scripps College **1975**

2.

Front and back cover: (detail),
Portrait of Moholy-Nagy. Photograph, n.d., 10¹/₁₆″ x 8″.
Below: Photograph, n.d., 2⁵/₁₆″ x 2³/₁₆″.

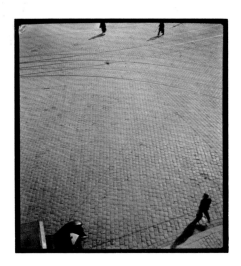

Participating Institutions

Galleries of the Claremont Colleges
April 4- May 8, 1975
San Francisco Museum of Art
July 8- August 24, 1975
University Art Museum, University of New Mexico
September 28- November 2, 1975

3. Photogram, 1929, 9⁵⁄₁₆″ x 11¾″. *Inscribed on back:* Moholy-Nagy 29

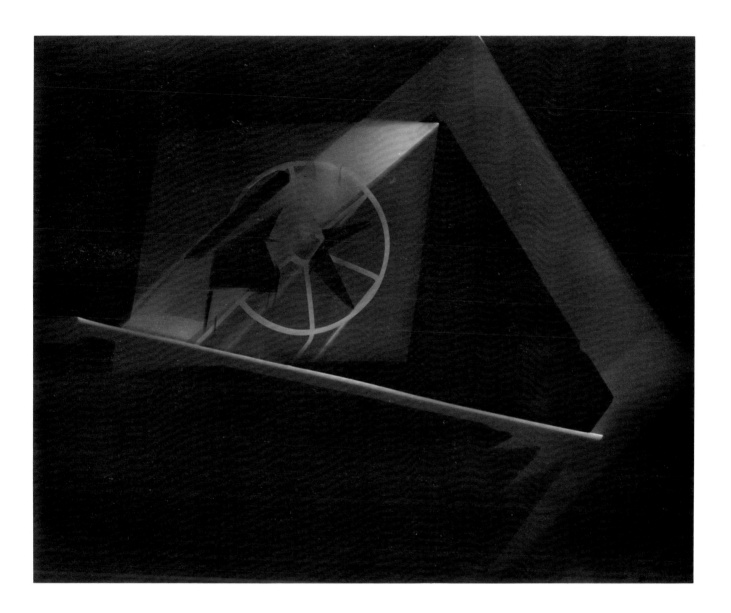

Acknowledgments

The Galleries of the Claremont Colleges held its first large photography exhibition three years ago when it co-sponsored *From 1839, Revolution in a Box* with the University Museum of the University of California, Riverside. Last year the Galleries exhibited *Light and Substance*, the fine exhibition organized by the University of New Mexico Art Museum. Recently, we began to purchase photographs to build a small study collection. This year along with the University of New Mexico Art Museum we have organized the exhibition *Photographs of Moholy-Nagy*.

That Claremont has embarked on an active program in photography is due in large measure to the efforts of Leland Rice, Curator of Photography and a faculty member of Pomona College. We would like to thank him for his advice, time and energy. Without him this exhibition would not have taken place.

We are deeply endebted to the collector, William Larson, for offering to lend us his photographs to study and allowing us to organize them into a traveling exhibition. It is his generosity which has made this exhibition a reality. He further aided us by arranging the basic sequence of the images in the portfolio portion of this catalogue.

William Larson's decerning eye as a photographer enabled him to select the approximately seventy-five photographs and photograms that make up his collection from a larger body of Moholy-Nagy's photographic works. As a body, the collection represents an interesting record of a practising photographer's response to the work of a historic and innovative artist-photographer.

Lucia Moholy has been of great help in explicating the degree of collaboration in the early photograms and has aided us with dating a number of the photographs.

Professor Lloyd C. Engelbrecht of the Humanities Department, Indiana State University, Terre Haute, has kindly written a most thoughtful essay, and his advice and wise suggestions for other parts of this catalogue have been invaluable. We would like to thank Professor Henry Holmes Smith of the Fine Arts Department, Indiana University, Bloomington, for his insightful essay which helps to place Moholy's work within the context of the history of American photography.

We would also like to thank William Bolger for his aid in compiling the selected bibliography and Professors Richard Sheirich and Hans-Dieter Brueckner of Pomona College for their assistance in transcribing Moholy's often nearly illegible handwriting. Finally we thank Robert Overby for his fine design of this catalogue.

David W. Steadman,
Director, Galleries of the Claremont Colleges

Introduction
by Leland D. Rice

The artist, Laszlo Moholy-Nagy, made the following insightful statement slightly less than half a century ago: "It is unprecedented that such a 'mechanical' thing as photography — regarded so contemptuously in the creative sense — should have acquired in barely a century of evolution the power to become one of the primary visual forces in our life. Formerly the painter impressed his vision on his age; today it is the photographer."[1]

Within our century we have seen this most influential medium struggle for artistic acceptance. In its earliest stage, at a time when the whole art world was embroiled in a great aesthetic ferment, we find photography a distant, bashful follower. But, as the 1920's approached, new photographic concepts emerged and the medium was enthusiastically embraced by the general art community. Through this artistic recognition, following generations of sporadic critical praise, it was realized that not only photography, but all media had flexible boundaries, independent yet related to one another. The art world had to look with fresh eyes at the new aesthetic potentials this medium in combination with others presented.

One of the most talented and important artists of the 1920s was Laszlo Moholy-Nagy, a Hungarian working in Berlin. We know him primarily as a painter, but he also sculpted, designed and wrote books, made films, and explored, as few have since, the many faceted characteristics of photography. Of all the media in which he worked, Moholy's photography remains the least researched by his contemporary exponents. Infrequent reproductions in history books and even less frequent exhibitions of the work, have made it difficult to arrive at any clear estimation of Moholy's photographic *oeuvre*. But, despite the general inaccessibility of original prints to study, a number of historians of photography have devoted a sizable amount of space in discussing the importance of his contribution to the medium.

Few significant collections of his photographs exist. Aside from one other private collection, the modest holdings of the Museum of Modern Art and the International Museum of Photography at George Eastman House have been the only ones of note in the United States. We feel, therefore, fortunate to have in the William Larson collection, for the first time, the opportunity to study a comprehensive selection of original camera images and photograms by this master.

No one has approached photography with quite the investigative curiosity and accomplished design sense that Moholy displayed. He coupled the ideal of a "world made beautiful by design," with a fierce belief that technology could be molded to man's needs. As Nathan Lerner, a close friend and teacher at the old School of Design in Chicago, related in a talk on Moholy recently:

"What seems to be missing now is an innocence that was such a basic part of Moholy, as it is of all great visionaries and artists. . . . Without innocence the artist is only a skilled technician, and loses a traditional role as a witness to stir the conscience of society."[2]

What Moholy tried never to lose sight of was this greater sense of the unity of all things in relation to life, not allowing the "intellect" to be completely separated from "inner signals."

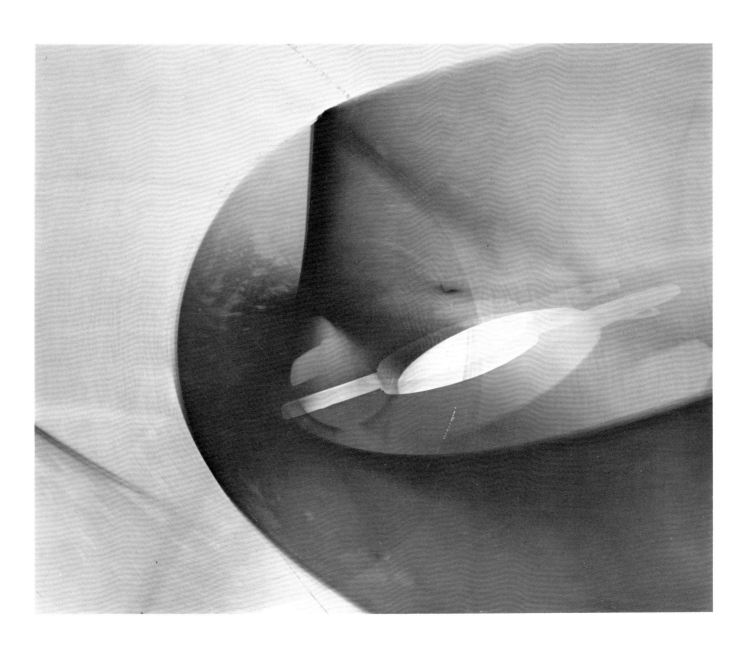

The following abbreviations for stamps appear in photograph captions.

 Berlin stamp: moholy-nagy / berlin-chbg. 9 / fredericiastr. 27 atelier
 Photo stamp: foto moholy-nagy

The translations are put in brackets.

Unless otherwise indicated, the photographs are untitled.

We do not know exactly when Moholy started making photographs. Sometime around 1922 he and his first wife, Lucia Moholy, began collaborating on making photograms (light sensitive images made without the use of a camera).[3] Concurrently he was intrigued with the possibilities of collage and was combining found objects with his drawings and paintings. We can assume, therefore, that photograms, photomontages, and camera images were all occurring simultaneously. Moholy was truly a multi-media phenomenon, a precursor of the prevailing artist type of today.

Although this is not the place to recount Moholy-Nagy's many sided achievements, it is worthwhile to discuss a few of his most fertile visual inventions. In so many ways they parallel directions which artists and photographers are following today and have become art conventions in the meantime. What we now accept as common photographic practices, were first explored as an ideology by Moholy. The concepts of photograms and photomontage are discussed at length in Henry Holmes Smith's essay elsewhere in this catalogue, so I will only attempt at this juncture to establish a general chronology in respect to those two areas.

One has only to consider the attitudes of the post World War I era to recognize the congestion of intellectual thought. Change became an article of faith, and art was approached as serious business. The emerging art movements of that time were Constructivism and Dada; both abhorring traditional approaches to art as bourgeois and obsolete. Artists in both camps likely influenced each other; El Lissitzky, one of the most important Constructivists was a close friend of Kurt Schwitters, then considered a Dadaist, and both knew Moholy. In fact, Moholy's studio in Berlin became a favorite meeting place for after-hour discussions on art. Moholy recalls the wealth of artists there:

"In 1922 the Russian artists, El Lissitzky, Ilya Ehrenburg and later Gabo, came to Berlin. They brought news of Malevich, Rodchenko and the movement called Suprematism. The Dutch painter, Theo van Doesburg, told about Mondrian and Neoplasticism, Matthew Josephson and Harold Loeb, the editors of "Broom," and the painter Lozovick, about the U.S.A. Then Archepenko, the sculptor, and Tristan Tzara and Hans Arp, both Dadaists, visited us. Joseph Peters and Vantongerloo came from Belgium, and the architects Knud Lonberg-Holm from Denmark, J.J. Oud and C. van Eesteren from Holland, Frederick Kiesler from Vienna, and Walter Gropius from Weimar. Berlin was for awhile the hub of the artistic efforts of Europe. "Der Sturm" of Herwarth Walden exhibited the pioneers of Cubism, Futurism and abstract art and printed the work of new poets. Already in Berlin were George Grosz, Kurt Schwitters and Raoul Hausmann, the German Dadaists . . ."[4]

With the development of multi-media techniques such as collage, montage, assemblage, and photos combined with painting we see the emergence of many challenging possibilities. Longstanding barriers between the usefulness of materials and flexibility of application began to disintegrate — the waste objects of the world became art in the hands of the artists of the twenties. This kind of work placed a new kind of burden on the viewer: the use of novel and unexpected materials, juxtaposed in such a way to elicit social and psychological responses had little to do with representation and everything to do with symbol. Photographic and printing reproduction processes contributed to the rapid emergence of the collage.

Moholy was strongly influenced by the Dadaists' collages and photomontages. But whereas theirs tended to communicate social and cultural values they tended to despise and belittle, Moholy's were invested with more personal, psychological responses to subject matter. As Beaumont Newhall points out in a taped conversation about Moholy: "His photomontages are very special. They don't have anything of the quality of the biting satire of Grosz and Heartfield, or Hanna Hoch and Raoul Hausmann. Rather they are objects suspended in space by his very beautiful draftsmanship and network of lines. It is another kind of ethereal world that Moholy is creating."[5]

His use of drawn lines created strong geometric forms similar to the flat planes and shapes found in his Constructivist paintings. Through coupling camera derived images that seemingly had no logical association with these synthesized geometric shapes, Moholy attained an evocative, disturbing image bordering on the surreal. Few artists or photographers have equaled his photomontages. Their acceptance and relevancy to the photographic world was largely overlooked until about the last decade.

The Larson collection is particularly rich in photograms. The photogram as a concept was a known, but generally unresolved technique in the pre-history of photography. It is well known that William Henry Fox Talbot used the technique to make impressions of leaves and lace in the year 1839. But, in those days they were viewed merely as realistic impressions of objects on light sensitive paper. It took over seventy-five years for a number of artists, independent of one another, to revive the process.

Moholy approached the photogram much like his painting — his "transparent" paintings (c. 1921) were completely detached from what he considered, "reminiscents of Nature."

"The liberation from the necessity to record was their genesis. I wanted to eliminate all factors which might disturb their clarity — in contrast, for example, with Kandinksy's paintings, which reminded me sometimes of an undersea world."[6]

He proceeded to articulate his painted forms as if screens of different shapes had been placed behind one another giving the effect of superimposed colored light. His use of what he called "neutral geometric forms" combined with the renouncing of physical texture variations, created an impersonal look to the pigment, and "brought about the change from traditional illusionistic rendering to 'painting.'"[7] It was these concerns that undoubtedly led him to experiment with photograms.

In his photograms we see him recreating some of the same feelings of light that we see in the paintings. The photographic paper acted as a neutral surface which complemented his intention to "dematerialize" the precise looks of an arrangement of objects to obtain a "new vision." The observer is no longer assaulted nor burdened by pertinent, realistically based, imagery. Rather, he stares at a series of flat, abstract patterns floating in a deep, plastic space. An unusual example of this effect is seen in the photogram 'Diagram of Forces,' (p. 34) where the paper itself, rather than objects acts as the modulator of the light. Moholy first took the paper and wetted it, then creased it so that the character of the creases left 'shadow' impressions as the then flattened sheet was exposed to changing positions of light. The paper expressed itself!

Other significant non-representational photo image methods were also being developed. As early as 1916 Alvin Langdon Coburn was leveling this challenge at the photography world:

"Why not repeated successive exposures of an object in motion on the same plate? Why should not perspective be studied from angles hitherto neglected or unobserved? Why need we go on making commonplace little exposures that may be sorted into groups of landscapes, portraits and figure studies? Think of the joy of doing something which it would be impossible to classify, or to tell which was the top and which the bottom!"[8]

Coburn proceeded to make abstract photographs by clamping three mirrors together and fitting them around the camera lens. He caught multiple reflections of pieces of glass, wood and other objects he placed in front of the camera (see Fig. 1). These he called vortographs, a term borrowed from another art movement known as Vorticism, the English variant of Cubism.

Another important, but neglected photographer who investigated light as subject matter, was Francis Bruguiére. Amongst his experiments was a series where he cut designs into paper which he then manipulated with light and photographed with a camera. He placed these paper-cut pieces into a low relief, usually lit by one small 250 watt spot light placed in different positions during a successive series of exposures. (see Fig. 3).

"Bruguiére has shaped panic with paper and light. He has shaped flight in likewise manner. Ambience. But this is not a narrative, this is an experience kinetic of what the eye knows does not move."[9]

Moholy's camera photographs have left their mark, almost a legacy, on all camera artists. Since his work with a camera, no photographer can ignore his fresh inventiveness of vantage point. Light remained fundamental, flexible and plastic, displaying familiar forms as abstract patterns. What was, at that time, an unorthodox vision of space, has today become an accepted perception. The static plane of eye level photography was found to be an unnatural solution to defining the plasticity of objects. Moholy comments about how the photographer could

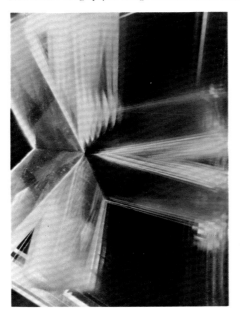

Fig. 1. Alvin Langdon Coburn. *Energy*, Vortograph, 1917, 8″ x 6″. International Museum of Photography at George Eastman House, Rochester, New York.

eliminate an undesirable horizon line to strengthen his perception of the subject:

"Today, (1946), photographs are often taken from above on an inclined surface or against a curved background, eliminating the horizon line. This allows a concentration on the object itself which no longer is cut haphazardly. Also, the contemporary photographer uses any number of light sources at various angles if they help him define his object better."[10]

Moholy took pictures just about everywhere on his travels. Some examples in this catalogue were taken in Finland, France, and Sweden. But, it would be misleading to consider his camera pictures as merely snapshots. His pictures are not arrived at accidentally. They are perceptively organized. One of his visual methods was to establish inter-post elements, where shafts of light and dark patterns distorted familiar perspectives, setting up tensions in which space contests with pattern for pertinency. Another way he created space was to photograph through different shapes, like a screen, a metal railing (p. 50), or overlapping machine-like structures (p. 33). Still in other pictures he would, either through choice of vantage point or selective focus of the lens, lead the viewer from the general to the specific (pp. 28-29).

Moholy used the camera as a tool for vision. From his earliest studies in art he was particularly interested in the mechanistic look of things and this was just what he trained his camera on. He continually found delight in discovering new forms through completely accidental means. Beaumont Newhall relates a marvelous occurrence in Carmel where Edward Weston was showing Moholy some of his prints:

"I was an onlooker. Moholy kept finding in the photographs hidden and fantastic forms, which were often only revealed when — to Weston's obvious, but politely hidden annoyance — he turned the print upside down. These afterproducts of Weston's vision fascinated Moholy: he considered photographs not interpretations of nature, but objects in themselves fascinating."[11]

It is believed that Moholy did little if any darkroom work. We know that Lucia Moholy did the technical manipulations in their collaborative efforts with the photogram, at least through 1928.[12] Upon receiving a selection of Moholy's photographs, first in 1941 at the Museum of Modern Art and then after his death another selection purchased by George Eastman House, Newhall offers these observations:

"All of these photographs were approximately 11 x 14 inches in size on glossy double weight paper. All the camera images were processed commercially and many of the photograms were actually copyprints. I think Moholy did very little darkroom work. Certainly so far as his camera pictures were concerned. He had no interest whatsoever in what we call the 'fine print.' To him the image which the camera or the photogram could capture was the exciting thing. This was true to such an extent that, so far as I know, all of his work in the later years of his life was done in Kodachrome in the form of slides. He once said that if his seeing was not strong enough to stand up to the routine processing of the corner drugstore then he wasn't seeing in a challenging way.

How true this is, I think, can be illuminated by the following anecdote, which occurred when Ansel Adams and I were hanging the first exhibition of the Museum of Modern Art collection in 1941. Ansel was shocked by the quality of Moholy's famous picture of the view looking down from the radio tower in Berlin. So, I suggested that we ask Moholy if

he would lend us the negative and then Ansel could make a really fine print from it. Moholy was delighted to oblige, and Ansel made a beautiful print. But Moholy's print completely fell apart; it was no longer an abstraction, but a record of melting snow and a park scene."[13]

To Moholy the photograph was to be experienced simply as a means of vision:

"We have hitherto used the capacities of the camera in a secondary sense only. This is apparent in the so-called 'faulty' photographs: the view from above, from below, the oblique view, which today often disconcert people who take them to be accidental shots. The secret of their effect is that the photographic camera reproduces the purely optical image and therefore shows the optically true distortions, deformations, foreshortenings, etc., whereas the eye together with our intellectual experience, supplements perceived optical phenomena by means of association and formally and spatially creates a conceptual image. Thus in the photographic camera we have the most reliable aid to a beginning of objective vision."[14]

Through Moholy-Nagy's photography, curious as it may be, we have the opportunity to view the universe with new vision. He worked at a time when all the visual arts were intermingling with one another. No previous period embraced photography as Moholy's did.

Some half a century later we find ourselves in the midst of another Renaissance of photographic activity. And once again there are a number of equally significant movements with which to cast our lot. What we should not lose sight of is the legacy that an artist like Moholy-Nagy leaves us. For he truly helped transform the medium of photography into a promising vehicle of creative potential, independent from, yet related to, all the visual arts.

1 *American Photography*, VL/1, January, 1951, p. 7.
2 From a transcript of talk by Nathan Lerner given at the Institute of Design reunion, Chicago, May 11, 1974.
3 Lucia Moholy. *Moholy-Nagy, Marginal Notes: Documentary Absurdities*. Krefeld, Germany: Scherpe Verlag, 1972, p. 59.
4 Laszlo Moholy-Nagy. *The New Vision 1928*. 4th rev. ed., 1947, and *Abstract of an Artist*. New York: Wittenborn, Schultz, Inc., 1949, p. 80.
5 From a transcript of taped remarks made for Alice Swan by Beaumont Newhall in November 1973 and kindly made available to this writer.
6 Laszlo Moholy-Nagy, *op. cit.*, p. 75.
7 *Ibid.*, pp. 76, 79.
8 Nancy Newhall. *Alvin Langdon Coburn*. Rochester, New York: George Eastman House, 1962, p. 13.
9 Harry Alan Potamkin. "Francis Bruguiére Photo." *Transition*, 18, 1929, p. 81.
10 Laszlo Moholy-Nagy. *Vision in Motion*. Chicago: Paul Theobald and Company, 1947, p. 117.
11 Beaumont Newhall. *Photo notes*, March, 1948, unpaged.
12 From a letter, Lucia Moholy to Leland Rice, December 28, 1974.
13 Beaumont Newhall, from transcript of taped remarks (see footnote 5).
14 Laszlo Moholy-Nagy. *Malerei, Photographie, Film*. Bauhausbücher 8, Munich: Albert Langen Verlag, 1925; idem. *Malerei, Fotografie, Film*. 2nd ed., Bauhausbücher 8, Munich: Albert Langen Verlag, 1927. The first English translation appeared in 1969; idem. *Painting, Photography, Film*. Translated by Janet Seligman. Cambridge, Massachusetts: The M.I.T. Press, 1969, p. 28.

Laszlo Moholy-Nagy:
Perfecting the Eye by Means of Photography
by Lloyd C. Engelbrecht

Laszlo Moholy-Nagy sought to intensify and to give emotional content to the optical, spatial and material experiences of modern man in order to create an art which would play a vital role in improving and humanizing modern industrial society.

Moholy was a painter, sculptor, print maker, industrial designer, interior designer, typographic designer, exhibition designer, stage designer, writer and teacher as well as a film maker who was also a distinguished still photographer. Though not an architect or planner, he frequently wrote and lectured on architectural subjects.

In addition, Moholy was fascinated with the possibilities of the direct manipulation of light. He described imagined shows which were to consist of the play of light on artificial mists. His famous power-driven device, *Lichtrequist einer elektrishen Bühne* (requisite light for an electrical theatre), best known in English as Light-Space Modulator, offered an infinite variety of visual-spatial experiences, in rooms of differing shapes and sizes, through interaction with natural and colored light. Typically, even these possibilities were extended in his film, "Lichtspiel Schwarz-Weiss-Grau" (Light Play Black-White-Gray), which featured the moving, illuminated *Lichtrequist* in dissolves, multiple images, juxtapositions and other cinematic devices.

The foregoing passages may make Moholy's professional activities seem diverse to the point of dilettantism. But that is because our language forces us to use many different terms to describe them. In fact, Moholy believed that all of his activities were directed toward the same goal, whether he was painting, making films or photographs, designing, teaching, writing or lecturing: giving form and emotional content to the new experiences of a modern industrial world in order to enable men and women, with the emotional as well as the intellectual side of their beings, to "redirect the industrial world toward a balance between a biologically sound human existence and the present industrial society."[1]

While Moholy believed that all would benefit from the direct experience of working with the elements of art, he also maintained that it was the role of the professional artist to express "the spiritual state of his age." And all of his work bears evidence that he took this high standard of professionalism seriously.

Although he devoted much of his career to art and design education, Moholy himself, curiously, had very little formal instruction in art. As a young child, he was attracted to the then new photographically illustrated popular magazines, forerunners of magazines such as the American *Life* and *Look*. This, along with his interest in poetry, later directed his attention to avant-garde magazines which combined poems, short stories, literary criticism, reproductions of recent art, scores of new musical compositions, and political and social comment. Both the popular and the avant-garde magazines were decisive early educational influences on him.

He also learned much, in an informal way, from the artists he knew personally in his native Hungary and in Berlin, where he settled early in 1920. But his formal training in art was confined to a brief period after he returned from service in World War I when, he once wrote, "I spent my evenings in a free art school and learned to

9.

Lucia Moholy. *Portrait of Moholy-Nagy*, Modern print from original negative, 1925 or 1926, 11″ x 8″.

draw nudes, and during the day I worked passionately at drawing landscapes, figures, portraits."[2]

Moholy was born July 20, 1895, in Bácsbarsòd, a small village in southern Hungary. His father soon deserted the family and disappeared into the United States, and the family was supported by an uncle who was a lawyer.

It is not exactly clear how young Laszlo came to have the surname Moholy-Nagy. By one recent account, the family name was Nagy, and Moholy was later added to the name. It was derived from the name of a village, Mohol, near which the family had once lived.[3] In another recent account, the artist's original name was Laszlo Weisz, but the last name was changed in favor of that of his lawyer uncle, whose last name was Nagy; in 1918 Moholy was added.[4] It has become customary, when not using his full name, to refer to him simply as Moholy. This usage began while the artist was still living.

Studies in law at Budapest were interrupted by service in the Austro-Hungarian Army as an artillery officer. Moholy entered the army on August 3, 1914, and was sent to the Russian Front. After hospitalization for shell shock, he was sent to the Italian Front, where around the end of 1916 he was wounded in a battle along the Isonzo River in Venezia Giulia.[5]

During long periods spent recovering from shell shock and from his wound, Moholy continued his interest in poetry and resumed an interest in drawing dating from his childhood. During a stay in Szeged, he was active with a short-lived literary magazine, *Jelenkor* (Modern Era).[6] Its first issue appeared in November, 1917, and it lasted only until the following April. Moholy served on the editorial board and also contributed poetry, short stories and book reviews.

Moholy returned to his legal studies in Budapest after the war's end, but never completed them. By late 1919, he was back in Szeged, working full time as an artist and exhibiting his work there.[7]

Most of Moholy's work from about 1919 to 1921 alternated between representational drawings executed in thick, bold lines which often achieved a touching eloquence, and collages, drawings, paintings, woodcuts and linoleum cuts devoted to gears, wheels and pieces of "machinery" presented in the nonsense Dada spirit which pervaded Europe during those years. After these youthful experiments, his paintings and sculpture during the rest of his life constituted a continuous and coherent effort to articulate and to intensify light and space in abstract and near abstract forms and environments created by the artist. Transparent solids and beams of light provided a point of departure for his paintings, and his sculpture and "space modulators" are only a further development, in which direct use is made of transparencies and the play of light. His best paintings are fascinating and exquisite essays in light, space, form and color and constitute a unique manifestation within the international Constructivist movement.

Moholy later related his whole career as an artist to this transition in his work around 1921:

"... I planned three-dimensional assemblages, constructions, executed in glass and metal. Flooded with light, I thought they would bring to the fore the most powerful color harmonies. In trying to sketch this type of 'glass architecture,' I hit upon the idea of transparency. This problem has occupied me for a long time.

The capabilities of one man seldom allow the handling of more than one problem area. I suspect this is why my work

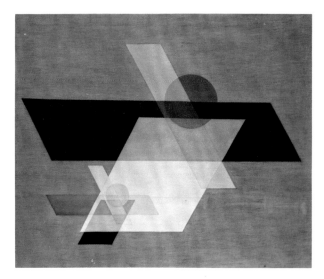

Fig. 2. *A II*, Oil on canvas, 1924, 45½" x 53½". Solomon R. Guggenheim Museum, New York.

since those days has been only a paraphrase of the original problem, light . . . Painting transparencies was the start. I painted as if colored light was projected on a screen, and other colored lights superimposed over it . . .

My 'transparent' pictures around 1921 became completely freed of elements reminiscent of nature . . . I wanted to eliminate all factors which might disturb their clarity . . ."[8]

A good example of the kind of work to which Moholy was referring is his painting "A II," of 1924, now in the Solomon R. Guggenheim Museum in New York (see Fig. 2), a work which is visually akin to several photograms in this exhibition. Lucia Moholy has recently described the interrelationship of paintings and photograms in her husband's work:

". . . there has been a certain amount of mutual influence between the two categories: photograms suggesting ideas for paintings and vice versa."[9]

Moholy's first one man show, held in February, 1922 in the Berlin gallery *Der Sturm*, neatly documented the transition in his work and perhaps firmed the artist's resolve to continue in the new direction.[10]

Along with new directions in his painting and sculpture came Moholy's first active interest in photography, an interest he developed in common with his first wife, Lucia. The two met in Berlin in April, 1920, and were married January 18, 1921.[11] They separated in 1929 and were divorced in 1934.[12] Lucia Moholy, presently a resident of Switzerland, is a photographer and writer with a well-deserved reputation of her own.

Lucia Moholy has described how she and her husband turned to the photogram, or photography made without a camera:

"During a stroll in the Rhön Mountains in the summer of 1922, we discussed the problems arising from the antithesis Production versus Reproduction. This gradually led us to implement our conclusions by making photograms, having had no previous knowledge of any steps taken by Schad, Man Ray and Lissitzky (or others for that matter). . . . The deliberations which formed the basis of our activities were published in *De Stijl* 7/1922 [volume V, number 7, Juli, 1922, pages 98-100] and reprinted in other magazines."[13]

Concerning the nature of these early experiments, she wrote:

For our first efforts in the art of the photogram, we chose daylight paper which allowed us to watch every phase of

the design during the entire process. The same kind of paper was, presumably on account of just this range of practicability, later used in courses of photographic instruction; so, for instance, at the New Bauhaus in Chicago. Papers for artificial light, in those days called gaslight papers, had been on the market for some time; but we lacked the necessary experience as well as the technical facilities for using them to advantage . . .

Photograms on a paper base were, by their very nature, unique. Duplication by contact printing was not feasible. If, beyond the economies and technicalities imposed upon us, there was in our minds an intention to create unica, it has slipped my memory. Be that as it may: the photograms produced in those days, with the exception of a few meant to be used for design purposes, were unique, and known to be unique."[14]

Christian Schad had called his photographs made without a camera "Schadographs." Man Ray called his "Rayographs." Moholy preferred the more impersonal word "photogram," now the term universally used.

In 1923, Moholy and his wife moved to Weimar where Moholy taught at the Bauhaus, a school of art and design headed by architect Walter Gropius: The Bauhaus did not have classes in photography until much later (beginning in 1929, which was after Moholy had left), but Lucia continued her interest in photography by gaining experience through working with a Weimar photographer and through classes at the Academy of Graphic Art (*Akademie für Graphische Künste und Buchgewerbe*) in nearby Weimar. In the evenings Laszlo and Lucia continued their collaboration in a temporary darkroom. New buildings for the Bauhaus in Dessau in 1926 provided a proper darkroom as part of their living quarters, thus allowing a greater scope for their experiments.

Lucia Moholy has recently written:
". . . practically all photograms prior to 1928 were done by collaboration between Laszlo and Lucia Moholy-Nagy, his being the pictorial ideas and elements, hers the control of the optical and chemical processes, the contribution of both equally indispensable to the results, and . . . an appreciable number of those photograms were subsequently photographed by her, the whereabouts of these negatives being unknown."[15]

Photograms made by Laszlo Moholy-Nagy after 1928 were accomplished without the collaboration of Lucia Moholy.

At the Bauhaus in Weimar and later in Dessau, Moholy taught in the foundation course and was head of the metal workshop. But it was the example of the work in photography of Moholy and his wife, and the effective use of photography in the Bauhaus books edited by Moholy and Gropius, with an assist from Lucia Moholy, which helped to turn the Bauhaus toward formal instruction in photography. Especially notable among the Bauhaus books in this respect was number eight in the series, *Malerei, Photographie, Film* of 1925; two editions appeared while Moholy was still at the Bauhaus.[16]

After his departure from the Bauhaus in 1928, Moholy supported himself by working as a free lance designer, photographer and film maker in Berlin, Amsterdam and London. In 1937 Moholy and his second wife, Sibyl, whom he had met in 1931, and their two daughters settled in Chicago, where Moholy had been invited by the Association of Arts and Industries to organize and direct a new design school.

The Association of Arts and Industries had been organized in 1922 to raise the standards of design in Midwest manufactures, but the group had difficulty in reconciling its turn-of-the-century Arts and Crafts orientation with modern industrial methods. After an abortive attempt to subsidize a design curriculum at the School of the Art Institute of Chicago, it finally moved resolutely into the future by turning to a Bauhaus approach and engaging Moholy to organize a new school which he promptly dubbed "The New Bauhaus; American School of Design."

In spite of a brilliant beginning which had attracted national and international attention, the New Bauhaus folded after one year due to the financial collapse of the Association of Arts and Industries. But Moholy and nearly all of the New Bauhaus faculty went on to start an independent school called "The School of Design in Chicago," which held its first classes early in 1939. After scraping along with a mostly unpaid faculty in its early months, it attracted the attention of Walter P. Paepcke, a former board member of the now defunct Association of Arts and Industries. Paepcke was then president of the Container Corporation of America and was convinced of the value of good design to modern industry. He was intrigued with Moholy's methods, and became a financial supporter and fund raiser for the school and an articulate interpreter of Moholy's approach and educational practices to leaders of business and industry. Paepcke helped reorganize Moholy's school in 1944 as the Institute of Design, now usually simply called "the I.D." Moholy continued to head the school until his early death from leukemia on November 24, 1946.

In the summer of 1940 the School of Design in Chicago presented a special visiting session at Mills College, Oakland, California, at the invitation of the late Dr. Alfred Neumeyer. The session took place from June 23 until August 3 and the faculty included Moholy, Gyorgy Kepes, Mrs. Marli Ehrmann, James Prestini, Charles Niedringhaus and Robert Jay Wolff. Simultaneously, Moholy showed his photographs and photograms at the Pageant of Photography in the Palace of Fine Arts at the Golden Gate International Exposition from July 1-15. The work shown at that time might have included items in the present exhibition.

The first classes in photography at the New Bauhaus in 1937 were taught by Henry Holmes Smith, a young artist, designer and photographer, who had been attracted to Moholy through *The New Vision* and other publications. The students in his classes in the first year included Arthur Siegel, Nathan Lerner and Leonhard Nederkorn, each of whom later became a distinguished photographer. In addition to Smith and Moholy himself, those Moholy engaged to teach photography included Gyorgy Kepes, Frank Levstik, former students Lerner and Nederkorn, and others.

It was in 1946, during Moholy's last year of life, that renewed emphasis on the study of photography became possible in the I.D. Beginning with the Spring semester, the enrollment was greatly increased, principally due to returning war veterans. There was also an upsurge nationally of interest in photography, in part owing to Moholy's enthusiasm and his ability to communicate that enthusiasm to the general public. At the opening of the Spring semester, former student Arthur Siegel was brought back as head of a newly instituted Department of Photography. Soon a four year curriculum in photography was begun, leading to the degree of Bachelor of Arts in Photography.

To launch the program, Moholy and Siegel presented a six week long summer symposium called "New Vision in Photography." A program of lectures, seminars, exhibitions and other activities was led by Berenice Abbott, Erwin Blumenfeld, Gordon Coster, Frank Levstik, Beaumont Newhall, Ed Rosskam, Frank Scherschel, Paul Strand, Roy Stryker, Weegee and Moholy and Siegel.[17]

Moholy, through his own work, his writings and his pioneering educational efforts, has had a profound influence on photography. This is so in part because classes in photography taught as an integral part of a broad curriculum constituted an innovation in photographic education, almost unheard of elsewhere before the end of World War II. Previously nearly all photographers were either self-taught or served as apprentices for other photographers, or studied in brief how-to-do-it courses in commercial art schools. This is a fact easily overlooked at the present time, when it is commonplace to find courses in photography as part of the curriculum in university and college art and design departments and in quality independent art schools.

One aspect of Moholy's practices during his earliest efforts in photography, when he worked in a creative interaction with his wife, Lucia, was continued throughout his life. His own enthusiasm made photography seem exciting to others and Moholy, in turn, was quick to catch the excitement and explore the implications of the inventions and discoveries of those he had inspired.

While his output as a film maker was mostly confined to the years 1929-36, Moholy's work as a photographer continued with no real break from his first efforts in the medium in 1922 until his death in 1946. Although a few of the areas Moholy explored, such as color photography and the photomontage, are not represented, the work included in this exhibition gives a good view of Moholy's achievements as a photographer. One can see a rich selection of his collaborative and his independent work in the medium of the photogram, his "conventional" photographs which constantly startle us by unexpected points of view, and his fascination with naturally occurring light displays of projected shadows. And all of the work in the exhibition serves as compelling arguments for his basic approach to photography as put forth in his posthumous book *Vision in Motion* (1947):

"The enemy of photography is the convention, the fixed rules of the 'how-to-do.' The salvation of photography comes from the experiment. The experimenter has no preconceived idea about photography. He does not believe that photography is only as it is known today, the exact repetition and rendering of the customary vision. He does not think that the photographic mistakes should be avoided since they are usually 'mistakes' only from the routine angle of the historic development. He dares to call 'photography' all the results which can be achieved with photographic means with camera or without; all the reaction of the photo sensitive media to chemicals, to light, heat, cold, pressure, etc."[18]

1 Laszlo Moholy-Nagy. *Vision in Motion*. Chicago: Paul Theobald and Company, 1947, p. 22.

2 László Péter. "The Young Years of Moholy-Nagy," *The New Hungarian Quarterly*, XIII/46, Summer, 1972, p. 70.

3 Lucia Moholy. *Moholy-Nagy, Marginal Notes: Documentary Absurdities*. Krefeld, Germany: Scherpe Verlag, 1972, pp. 8, 52.

4 Péter, *op. cit.*, pp. 61-63. It should be noted that Lucia Moholy recalls the lawyer's name as Stein, not Nagy (from a letter, Lucia Moholy to Lloyd C. Engelbrecht, December 30, 1974).

5 The published accounts of Moholy's experiences in World War I are fragmentary and contradict each other in some details. See Péter, *Ibid.*, pp. 67-69; Solomon R. Guggenheim Foundation, *In Memoriam Laszlo Moholy-Nagy; The Solomon R. Guggenheim Foundation Presents a Survey of the Artist's Paintings and Plastics at the Museum of Non-Objective Painting . . . May 15th to July 10th, 1947.* New York: Solomon R. Guggenheim Foundation, 1947, p. 24; Sibyl Moholy-Nagy. *Moholy-Nagy: Experiment in Totality.* New York: Harper and Brothers, 1950, pp. 8, 82; and *idem. Moholy-Nagy: Experiment in Totality.* 2nd ed., Cambridge, Massachusetts: The M.I.T. Press, 1969, pp. 8, 82.

6 Péter, *op. cit.*, pp. 69-70. It is sometimes stated that Moholy was a co-founder of the better known journal, *Ma*, which means Today, but these assertions are untrue and are probably due to a confusion between *Jelenkor* and *Ma*. Certainly Moholy must have read every issue of *Ma* since its founding in 1916, and he saw many of the exhibitions the magazine held in Budapest, but his active role with *Ma* probably dates no earlier than 1921, when Moholy had moved to Berlin and *Ma* had moved to Vienna.

7 *Ibid.*, pp. 70-71.

8 Laszlo Moholy-Nagy. *The New Vision 1928. 4th rev. ed., and Abstract of an Artist.* New York: George Wittenborn, Inc., 1947, pp. 72, 75.

9 From a letter, Lucia Moholy to Lloyd C. Engelbrecht, November 30, 1974.

10 Der Sturm, *Hundertfünfte Ausstellung, Februar 1922: Moholy-Nagy, Peri [und] Gesamtschau des Sturm.* Berlin: Der Sturm, 1922. This was number 105 in a long series of exhibitions organized by Herwarth Walden in his now famous gallery in Berlin. Walden, a musician and composer, also edited a journal called *Der Sturm*, founded in 1910, in which he presented avant garde material reflecting his wide ranging interests in music, literature, art and political and social issues. This journal, which was undoubtedly known to Moholy from his early years, served as a model for countless other journals, including *Ma*.

11 Lucia Moholy, *op. cit.*, pp. 7, 51.

12 From a letter, Lucia Moholy to Lloyd C. Engelbrecht, December 30, 1974.

13 Lucia Moholy, *Marginal Notes, Ibid.*, p. 59.

14 *Ibid.*, pp. 61-62.

15 From a letter, Lucia Moholy to Leland Rice, December 28, 1974.

16 Laszlo Moholy-Nagy. *Malerei, Photographie, Film.* Bauhausbücher 8. Munich: Albert Langen Verlag, 1925; *idem. Malerei, Fotografie, Film.* 2. Aufl., Bauhausbücher 8. Munich: Albert Langen Verlag, 1927. The first English translation appeared in 1969; *idem. Painting, Photography, Film.* Translated by Janet Seligman. Cambridge, Massachusetts: The M.I.T. Press, 1969.

17 Siegel, it should be noted, is again heading the photography program at the I.D., now a part of the Illinois Institute of Technology.

18 Laszlo Moholy-Nagy. *Vision in Motion*, p. 197.

Photogram, n.d., 7" x 5".

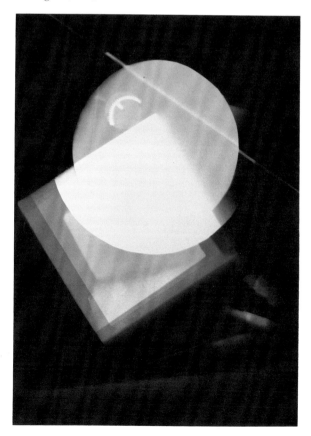

Across the Atlantic and Out of the Woods:
Moholy-Nagy's Contribution to Photography
in the United States
by Henry Holmes Smith

This essay proposes to describe the state of photography in the United States prior to Moholy-Nagy's arrival in 1937 and to account for the extended delay between the time when certain prospects for photography were announced by Moholy and the present relatively widespread acceptance of those ideas and practices.

Photography in the United States after the First World War was ready for a number of important changes, some of them concerned with commercial applications of the art and others with directions exhibition photography should take. Both conservative and radical choices were available, the most radical "conservative" position in exhibition photography consisting of camera and lens photography undeviatingly pursued to create intense images right next door to the less deeply motivated work for advertiser and editor.

Other options, equally "pure" but far less conservative in appearance, included the shadow picture (photogram or Rayogram), light play image produced with or without camera and lens and the assemblage of photographic pieces sometimes combined with a drawing or diagram. These found some small place with advertiser and editor but were largely excluded from exhibition photography. Although art journals of the twenties and a few photography periodicals from time to time did publish photographs in the stark camera and lens tradition, they paid only slight attention to non-camera photography and the photomontage that used photographic pieces in new combinations.

In a not unexpected turn of events, the United States in the 1920's saw the industrialization of printed matter, most particularly the mass production of both weekly and monthly periodicals with huge national circulations for that time. It became an ever clearer force exerted on photography, largely through the patronage of the advertiser. At the same time that photography turned more conservative in the service of merchant, manufacturer and editor, the leading new art form of photography took a surprising tack in the same direction, although it was not seen that way at the time.

This new conservatism, taking the best from Nineteenth Century photography and adding certain aesthetic concepts easily adaptable from Twentieth Century painting, faced off against a familiar opponent — the weak imitative version of the Art Photography practiced twenty years earlier by such turn of the century greats as White, Kasebier, Steichen and Stieglitz. The restatement of totally worn-out aesthetic and photographic principles was seen frequently in camera club events, minor national shows and the annual get-togethers of such groups as the Pictorial Photographers of America or predecessors and auxiliary groups. Drawing on the strengths inherent in the direct photographic processes and the integrity of lenses formulated during the years around the turn of the century, the new conservatism in photography took on all the appearance of radical picture making when contrasted with the soft focus work, the generally unmeant and unfelt imagery of the pictorialists whose art, however technically demanding, was an avocation and relaxation from other more seriously pursued duties in medicine, law, finance and business.

Photography has ever been in debt to painters and,

of course, the opposite is true as well although less boldly exposed. We cannot discount the contributions of men and women who have been almost entirely devoted to the photograph; for example, Julia Margaret Cameron and Gertrude Kasebier in their time and Imogen Cunningham and Berenice Abbott in ours. Nevertheless, from Daguerre and Hill on past Delacroix, Degas, and many others through Edward Steichen in 1900, and the plethora of painters and printmakers at the present who demonstrate knowingly the contemporary ways to get the most from the medium, all these have offered unique inventions or visions and special insights to the larger body of photographers. Payment of such debts sometimes comes slowly and always in current coin.

It ought not be altogether surprising then to find that slightly more than fifty years ago Laszlo Moholy-Nagy, who regarded himself primarily as a painter, and Lucia Moholy, a skilled photographer who was at that time his wife, joined forces to produce some of that special work with its unique vision and surge of energy we now recognize as a major contribution to the new directions in photography, which has only in the last two decades, occupied a position of any prominence in the published work on photography.

The circumstances in which this collaboration was undertaken has been described in Lucia Moholy's recent memoir, an indispensable reference which should be consulted for details.[1] As Lucia brought professional skills, discipline and photographic expertise to the collaboration, Moholy brought the inventiveness, the high energy that was his heritage, and infectious enthusiasm. These characteristics caused him to become an enduring force in the propagation of strange, important ideas about photography and education some fifteen years later in the United States. It is now evident that he was to become the most important public advocate of the new photography in its early years in a New World that was either hostile or indifferent to its possibilities. Until his untimely death in 1946, Moholy's writings and public lectures, as well as his art, and in later years the work of colleagues, students and other loyal supporters all contributed to a sustained effort to help this new work find its rightful place in the larger body of art. Strangely though, what I consider his own major accomplishment to extend the reach of photography — the photomontage and what he also called "photoplastic" pieces in which the conventional structure of a camera photograph was subordinated or almost totally disregarded in the larger structure in which it was placed among other elements — has had far less influence than I wish it might have exerted. At its best, this form can cross over and outside the region of camera photography into that realm where personal experience is difficult to picture and the deeper insights available to individuals, whether or not they are artists, are dealt with.

From one point of view, with regard to photography's future, Moholy came to the United States at a most opportune time for introducing the unfamiliar if not altogether new concepts of photography to a young and eager audience. Photography was undergoing one of its periodic revivals, partly as the result of the successful introduction of 35mm cameras, particularly the Leitz Leica and Zeiss Contax. As we still see, new hardware is one of the most persuasive ways to expand the audience for photographs, however self-centered that audience may prove to be.

Of far greater importance, however, was the exhibi-

14.

tion of historical photographs organized by Beaumont
Newhall in 1937 at the Museum of Modern Art and the
catalogue that was issued to accompany the exhibition.
Aided by Nancy Newhall, he produced for America the
first intelligent and comprehensive overview of photog-
raphy from its early beginnings in England and France.
For those of us in the hinterlands who were desperately
trying to discover what was going on, this first scholarly
historical book in English was an eye opener. Both exhi-
bition and landmark publication were the two cultural
events of the 1930's most likely to support the long-range
photographic program that Moholy was involved with.
One must also recall the exhibition of Walker Evans at
the Museum of Modern Art in 1938 and numerous other
shows at various other New York galleries during the
previous eighteen years.

These all had relatively small audiences as did the
work produced by the government-sponsored photog-
raphers who were working to amass that monumental
body of pictures in the projects directed by Roy Stryker
and his colleagues in the mid-thirties. Save for the exhi-
bition arranged by Newhall, these projects were pointed
toward specific general audiences. The Farm Security
Administration photographs and those of the Resettle-
ment Administration before that, however frighteningly
radical they may have seemed in content, were aestheti-
cally conservative. This was also true of the picture press
and the photography magazines. It was a timid time vis-
ually; in general, only simpering and giggling were per-
mitted; euphemisms were the way of the world and the
air brush was reached for on occasions beyond counting.
None of this would have interfered with Moholy's aes-
thetic position, as I understand it, but it created an atmos-
phere that restricted the forms photography was encour-
aged to take.

As if the conservatism of commercially oriented photog-
raphy of advertiser and publisher were not enough, an
even stronger influence was brought into play to prevent
some of Moholy's ideas from receiving the exposure and
acceptance that they merited, particularly the work
called photomontage and photoplastic. To understand
this influence, which is one that still holds sway over an
enormous body of photographers, we must go back a full
thirty-five years earlier to a minor event that subsumes
some major tendencies in photography throughout its
history. I refer to the fate of Steichen's ten photographs
accepted for the Champs de Mars Salon in Paris in 1902.

In the 1970s, with collectors of photography increas-
ing in almost geometric progression, it may seem unduly
grim to recall that since its birth the photograph has
been bowing and scraping at the doors of dealers, con-
noisseurs, collectors and many museums, not to mention
juries of those who practice the other arts. Two bulle-
tins from *Camera Notes* sum up the predicament.[2] In the
first brief note, signed by Alfred Stieglitz, he writes that
a Parisian jury of painters and sculptors of "international
repute" has accepted ten photographs by Eduard (later
Edward) Steichen along with one of his paintings and six
drawings, all of which will be hung in the prestigious
Champs de Mars Salon. The second note, shorter and
dated a month later, has been inserted in the periodical
after the press run. It reports that the photographs will
not be hung because of "jealousies and political intrigue"
and that Steichen "acquiesced under pressure," fearing
future discrimination against his paintings.[3] Several traits
held in common by many photographers are evidenced

in this anecdote. First, a deference to artists that implies
one may judge an art whether or not one is familiar with
its processes and products. Second, an almost supersti-
tious belief that things that resemble one another become
the same thing. Mutual jealousy of place, how the pho-
tographic artist is regarded by other artists, and mis-
placed trust in judgment of an indifferent jury complete
the list. We still find these all about us.

It seems quite clear that in this instance Stieglitz felt a
common bond with Steichen in his triumph and beyond
a doubt shared the humiliation, too. Unfortunately, the
rejection of the photographs by the Champs de Mars
Salon jury coincided with Stieglitz's resignation as editor
and main guiding force of *Camera Notes*.[4] Public rebuffs
of this nature are galling to anyone; to a man of Stieglitz's
pride and ambition for photography, repeated defeats
require direct response. In the twenty years that followed,
we see a variety of strategies adopted, all of them directed
toward answering actions such as that of the jurors in
Paris. First, and most immediately relevant, was the edit-
ing and publishing of the periodical, *Camera Work*, by
Stieglitz in 1903. This elegant and unmatched photog-
raphy periodical established a sounding board for the
photography so furiously dismissed at the Champs de
Mars Salon and elsewhere. When this answer proved less
than adequate, Stieglitz's response would be to find other
ways to deal with indifference. Shortly before the First
World War, he became involved with certain radical art-
ists who, in their own way, were attacking the conven-
tional artists who were still rejecting photography. At the
cost of losing his subscribers, Stieglitz changed the
emphasis in *Camera Work* to include illustrations of
drawings, paintings and sculpture that created problems
for many artists with established reputations.[5] Finally,
after most of his subscribers had abandoned him, he intro-
duced the photographs of Paul Strand to the remaining
readers, challenging accepted taste within the medium.
It was almost inevitable, then, that the next step would
be to elevate the direct style of photography and perfect
it for use by photographers of vision and insight. There
was irresistible logic for this move. This style of photo-
graph had long been regarded as "everybody's art" and
contained unique challenges to the conventions and
aesthetics of the art world of the early twentieth century.[6]

In Stieglitz's hands, and with his vision and energy
during the same years when Moholy-Nagy assisted by
Lucia Moholy began his first exciting photographic work
and companion photomontage and photoplastic assem-
blages, Stieglitz took camera work a giant step toward
the world of art. His pictures exploited confrontation of
the subject, found the rhythms of nature that best sup-
port lyricism, and in his studies of the city buildings also
provided a direct response to certain aspects of the geom-
etry related to cubists and other artists involved with
urban and industrial motifs. With his long series called
"Song of the Sky," he transcended the commonplace
aspects of "everybody's art" and set a standard which was
first a lively challenge and later photography's burden
for half a century. In my view, its compelling beauty and
logic made this standard an important limiting factor
in the acceptance of Moholy's new pictorial structures
that did not involve the camera.

Photography, as an intimate companion of the other
pictorial arts, however, was abandoned. By the time of
the Stieglitz show at the Anderson Gallery in 1921, it
would no longer be fashionable to seek the company of

15.

Broom, Photogram, 1922, 7″ x 5″.
Inscribed on back: L. Moholy-Nagy, *Skizze für das Titelblatt der Zeitschrift "Broom,"*
[Sketch for the titlepage of the magazine *Broom*] , Photogram, 1922

conventional pictorial arts appearing to wear similar dress and attempting to create the same effects. When photography was examined, it came under frequent and sharp attacks for its limitations including what appeared to be its mechanical nature and the peculiar ease with which its pictures were produced. Although this infuriated photographers, there was no simple convincing answer for anyone who could not or would not attempt to work with the medium.

From the mid-twenties on, for more than a generation, certain photographic practices became so important that they amounted to an official style. Reinforced by the preferences of the Newhalls, they also became for a generation a widely held museum taste. It should not matter what form these practices took but by coincidence they were those espoused by not only Stieglitz and Strand but also by others of not exactly similar mind.

In the long view, taste takes care of itself. The photographic form so important to Stieglitz is a case in point. Aspiring as it did to become the exclusive photographic style, this hope was doomed. Camera photography may be comforting, may help us relish the physical world and its incredibly various forms, may disturb us with reports that perhaps we should have seen but, nevertheless, its structures are much too simple and its psychology often too limited to help us through the rest of our experience, particularly that of the night, the interior cavernous world we try to hide from or within and also what we may now think of correctly as outer space. Probably no lens of human design has yet been built to cope with either our inner or the solar system's outer space. Yet, this has become a major part of our world.

Another considerable influence that attracted a large body of photographers away from the promise of Stieglitz and Strand was the public exposure of Steichen in the special showcases of *Vogue* and *Vanity Fair*. Some time after 1920 Hearst, with his uncanny knack for hiring away developed talent, brought Baron DeMeyer from *Vogue* to *Harper's Bazaar*. Conde Nast then made Steichen chief photographer of the two periodicals which immediately became a pair of monthly exponents of the new photography as used by editors and advertisers. Embarking on the third of his many long careers in photography, Steichen assumed a dominant role in forming the taste of young photographers in both the applied and exhibition areas. A master of high style and superb taste, he proved to be a virtuoso of camera and sharp lens. An intense feeling for surface texture combined with dramatic lighting and pose enchanted not only editor and advertiser but also the general reader . . . especially those who sought something stronger to follow than the camera clubbish work constantly printed in the old line photography magazines. In the hands of showmen such as Steichen, and there were a number, this style of camera work was extremely seductive, especially in the hinterlands, where ambitious, young photographers were looking for someone to guide them. For them, Steichen in the 1920's and 30's became the inspiration Clarence White and Stieglitz had been to the young Steichen in Wisconsin thirty years earlier. Stieglitz became more reluctant to have his photographs reproduced, rejected some opportunities to exhibit, and in general, provided less counteractive influence for photographers being seduced by this brilliantly printed, superb commercial photography. Thus, one more distraction, one more postponement of the day when young photographers would

be forced to re-examine what camera and lens photography could mean to them.

In the fall of 1935, T. J. Maloney had launched the long-lived *U.S. Camera Annual* with Edward Steichen serving as judge of the work submitted for publication until the year 1947. Within the following twelve months, *Life* was reborn as a magazine devoted to photo-journalism and *Look* began its career. Not too long thereafter, *U.S. Camera Quarterly* was introduced to join two brasher periodicals for the general reader on photography, *Popular Photography* and *Minicam*, both of which survived the downfall of a host of distinguished predecessors the last of which was *American Photography*. The new interest was strong, the response was real. Although the photography periodicals exerted a not altogether beneficial influence on the photography to come, the newer periodicals occasionally were involved later in publishing some of the ideas for which Moholy stood.

When these conservative "American Revolutionaries" in photography undertook to subsume all photography under the rubric of camera photography and, in the name of purity, prescribed this mode for all individuals, failing to acknowledge its limitations, they trapped themselves in the same corner with the artists who had rejected photography a generation earlier. Had they been less innocent, younger photographers might well have felt themselves short of options. One side informed them the way to art was by the camera; the other side insisted it was via the printing press, but first by way of the camera. To compound the problem even more, a distinction was made between the printed advertisement and the printed picture in the editorial columns. Through this maze, Steichen proceeded to lead the way, now speaking in the name of "communication."

By 1937 Stieglitz, old and ailing, had laid his camera aside. Steichen, on the other hand, now occupied a position of special power. *U.S. Camera Annual* was a direct confrontation with the *American Annual of Photography* and tended to take the part of the great advertising illustrators and other professional photographers of repute. It could not, however, accommodate existing work that, in the company of such pictures, would unquestionably look "freakish." Thus, in the absence of photography magazines on the lookout for the challenging concept and the new possibilities for photography, only a minute audience awaited the new work about to arrive in the United States in the company of Moholy-Nagy.

This predicament became a likely source of confusion and cause for distraction among photographers who were yearning to be told what to do. I see a difference between what the Stieglitz photographs stood for — a great river rolling steadily along very near a delta from which it will enter a wine dark sea; the photographs for the printed page as sponsored by Steichen and others following another, more turbulent, channel headed in the same general direction as the other river but its course more frequently changing, its destination some shallow inland sea soon to disappear as bog, landfill or subdivision. At that same time forty years ago, I see Moholy's work and those whose work was in that mode more like a stream near its sources in the mountains on the other side of a continental divide, tumbling abruptly down a rocky course a long way from its destination, perhaps never in our lifetime to reach the sea.

Another world of work remains to be done. From the first, Moholy-Nagy addressed himself to this work, and

much of what he produced is still a rich but neglected resource which needs more careful examination by better prepared exponents. Among these, the simplest technically, are the cameraless pictures — photograms, shadow pictures, or Rayograms — of which countless examples exist and which have been made by many photographers, from rank beginner to sophisticated master. Of all these, none except for Lotte Jocobi in my opinion, so consistently announces the play of light more exquisitely and subtly and none produces quite the exalted sense of mystery within which we and light are caught up than those produced by Moholy. I have felt this for forty years.

In the general excitement over rediscovered ways to exploit camera and lens photography, under the spell of virtuosi who were exponents of precisely delineated objects and crisply rendered surfaces and glowing play of light, it was nearly lost from view that the point of photography is light itself. Obviously, the play of light is central to all photography but when it is caught up in the objects over which it plays, the result is a magnificent confusion between the familiarity of the object and the magic of the light. Nevertheless, light is revealed only when it is interfered with — dispersed by particles of one kind or another as fog or smoke, reflected as from all kinds of surfaces, obstructed as when a shadow is cast or, most beautiful of all, redistributed, refracted or split into its colorful components. Any who cherish this sort of imagery, in which light and its possibilities for play are emphasized, seldom realize how little interference is needed to reveal the play of light and how much excess interruption occurs when objects are obviously introduced into the picture making method. This has been one of the traps for present day photographers using camera and lens. The solution often chosen was to produce pictures in which the objects were presented as partial puzzles. Francis Bruguiére's light sculpture and Moholy's photograms most firmly taught me this truth. The works of both (in two completely different ways), express intent to deal with light above all else. In pictures done by Bruguiére, objects were specially constructed to reflect light (modulate a simple beam) in a rich variety of ways (see Fig. 3). These objects were lighted and pictured so that the light effect was of primary importance and the object

itself, called a light shed by Frederick Sommer, was a subordinate, sometimes scarcely identifiable component of the picture. In the ordinary shadow picture, on the other hand, the silhouette is quite often the predominant effect and in many cases the silhouette identifies an object or shape that brings us up against the ordinary world of objects as bluntly as most camera pictures. Moholy's photograms, on the other hand, from the first, presented a brilliant method of dealing with light play quite different from but as important as the light sheds of Bruguiére. Once the viewer accepts the photographic fact that dark is the photographic mark of light, and that there is a direct relationship between the amount of light and degree of darkness, the photogram becomes quite easily interpreted for the light play it has recorded. Moholy's photograms provide us a splendid range of light play in which the *mystery* of light is the central visual force. Although a viewer may be aware that objects have been introduced between the light source and the sensitized surface, it was Moholy's genius to keep us from direct contact with them.

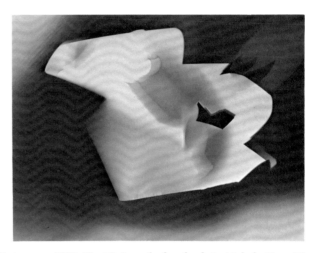

Photogram, 1939, 5″ x 7″. *Inscribed on back:* L. Moholy-Nagy 39

This added touch of mystery was a constant intent of Moholy's; an effect, along with the choice of shapes, that disengages the viewer from ordinary associations and permits a linkage with the possibilities of light itself. Since Moholy was fascinated with light play, one of the goals of his work was to help us feel the play of space best suited to the play of light. Deep dark across immense reaches, as in our solar system, would be one analog for what we see in these pictures. Token brights shine against mysterious darks; delicate modulations move subtly into the blacks and whites in the clean, precise structures containing messages of light. We are invited to contemplate this light; to marvel that it is a central function in our life; a sun so distanced that we are not destroyed; to consider the planetary spaces we now have measured but cannot comprehend.

Through the photogram, Moholy leads us into the reaches of these solar spaces using dark for light. Into the solar plexus, outward to the solar system, both of which are barely explored, hardly known and charged with energy and mystery, these remarkable pictures take us. Visual space ships for the imagination. They can do this largely because the shapes they create are discreetly disengaged from the objects that created the shapes. We are left dangling between the world we know and the worlds we know we should know more completely.

Fig. 3. Francis Bruguiére. *Untitled*, Photograph, c. 1925, 9⁵/₁₆″ x 7³/₈″. Mr. and Mrs. Leland Rice Collection.

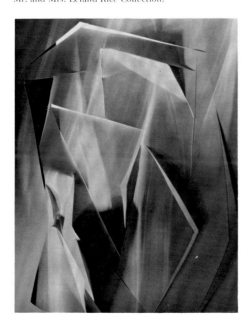

As I consider the information, the emotional content of what up to now has been reported coming back from our trips to the moon; films of solar events such as the flares and bursts of a magnitude so great that they extend in space a distance sufficient to embrace ten of our worlds side by side, I am awed at the force with which these light pictures convey some of this same feeling.

Even more important for the future of photography was the strange work almost totally disregarded in American publications and quite probably forbidden in all but the most eccentric exhibitions of photography — the photomontage and photoplastic examples which I first saw in *Foto-Eye* and *Fototek* published in 1929 and 1930, respectively. It would be preposterous to claim that Moholy-Nagy was the only one to make photomontage assemblies or that once the ground had been broken his themes were unique. Yet, like his photograms, these photomontage assemblies had a persuasive mystery, and many of them were obviously filled with references to personal experience. Today, with more complete information, certain of these pictures — for example, *Jealousy, The Shattered Marriage,* and *The Fool* — are rich with personal insights verified by events of the time.[7] I appreciate more than ever the feelings I first remember having when I saw these in the pages of *Foto-Eye* and *Fototek* for the very first time. This can be said without taking anything away from the work of Hannah Hoch, John Heartfield, George Grosz or Willi Baumeister, all of whom plowed different land. Just as Grosz and Baumeister enriched and enlivened some of their photomontages with drawings in their own styles, Moholy enhanced and completed his montages with connecting lines indicating spatial references and planar locations that await further exploitation today. In every instance these additional marks, anathema to all straight photographers, enlivened and enriched the visual ideas.

Fig. 4. *Jealousy,* Photomontage, 1925, 25¼″ x 18¼″. International Museum of Photography at George Eastman House, Rochester, N.Y.

I think it is here that Moholy brought more to photography than in any other mode. First, because it was a useful demonstration of an important means of introducing quite personal notes into the relatively impersonal medium and second, it demonstrated an extremely precise means of spatial control that unlocked the arbitrary, however comforting, picture space established by the photographic lens and tonal system.

The first time I met Moholy-Nagy was when he visited me at the darkroom where I worked in Chicago and asked me to help plan the darkrooms for The New Bauhaus, American School of Design. In deference to his reputation and because I had gained so much help from his pictures and his writings, I said that I would help in any way I could, but perhaps he ought to make the plans himself. He explained at once, simply, that he was not a photographer but a painter.

It was only in a technical sense that Moholy-Nagy was not a photographer. He understood the potentials of the medium as few others did in the third and fourth decade of this century. It was only through this understanding and by the energy and force of his mind, combined with his skill as a publicist, that he was able to find exposure in the press of this country for the strange new prospects for photography that he had brought with him from Europe. To this day, I remain in awe of the ease with which he moved from the theoretical to the practical. He was able to make use of an amazing variety of contacts in business and industry and establish the necessary contact with editorial resources at every level. It was this skill that enabled him to cope with one of the conservative forces that operated in the United States, the editorial bias that sought to prevent the "average" reader from being frightened by what he might see. The images of the other force, represented by the work of Stieglitz and that hardy band of straight photographers, were published side by side with Moholy's photomontages in *Foto-Eye.* Moholy, therefore, was perfectly at ease with their work, however ill at ease his work may have made them. That, in essence, was his genius.

Such was the stew of photographic possibilities in this country that prepared the young photographer to use photography in ways so revolutionary and strange that they are still seeking a proper place to settle in. Now, however, they seem to be finding some sort of home, at least among the younger photographers. Nevertheless, because of that unfortunate beginning, amidst the variety of conservative forces both within and without the fields of journalism and exhibition photography, my guess is we are still some forty years late with what is happening. If I am told, "Better late than never," I can only reply, "Not this late."

1 Lucia Moholy. *Moholy-Nagy, Marginal Notes: Documentary Absurdities.* Krefeld, Germany: Scherpe Verlag, 1972.
2 *Camera Notes,* July 1902, pp. 50-51 and unpaged insert.
3 *Ibid.,* unpaged insert.
4 *Ibid.,* p. 15. Stieglitz, in a short editorial, relates how, for a year, he had planned to devote an entire issue of *Camera Notes* to Steichen and his work. But because of the subtle quality of the original prints, he wanted to wait until Steichen returned from Europe so he could directly supervise the reproductions. In the meantime Stieglitz's resignation as editor made this impossible. He goes on to say how "regrettable" this is and that, "*Camera Notes,* which has fought so mercilessly for that cause embodied in Mr. Steichen's pictures and ideas, seems incomplete without the realization of the above referred to plan." When *Camera Work* was founded the next year Steichen was featured in the second issue.
5 *Camera Work,* from 1910 on contains plates of drawings, wash sketches, paintings and photographs of sculpture by Rodin, Matisse, Picasso and others, all capable of offending conventional artistic taste.
6 I have dealt with this problem in some detail in the following essay: Henry Holmes Smith. "New Figures in a Classic Tradition," *Aaron Siskind. Photographer.* Rochester: George Eastman House, 1965, pp. 15-23.
7 These pictures are reproduced on pp. 13, 47, and 35 respectively in *Fototek.* Berlin, Germany: Klinkhardt and Biermann, 1930.

The Dolls, Photograph, 1926, 9⅜″ x 7⅞″.

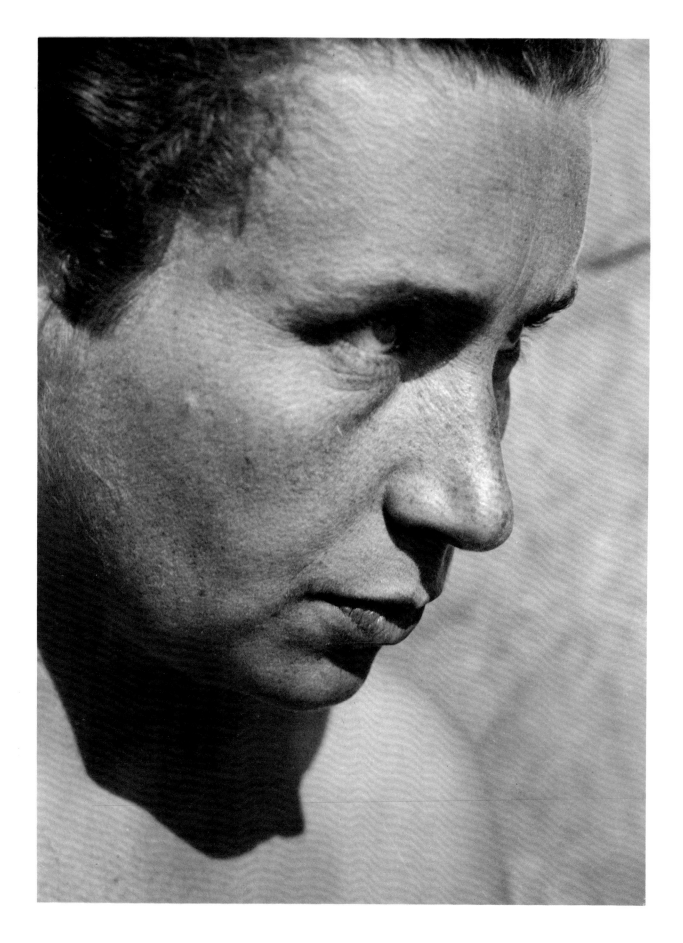

Portrait of Lucia Moholy, Photograph, Modern print from original negative, 1928 or 1929, 11″ x 8″.

21.

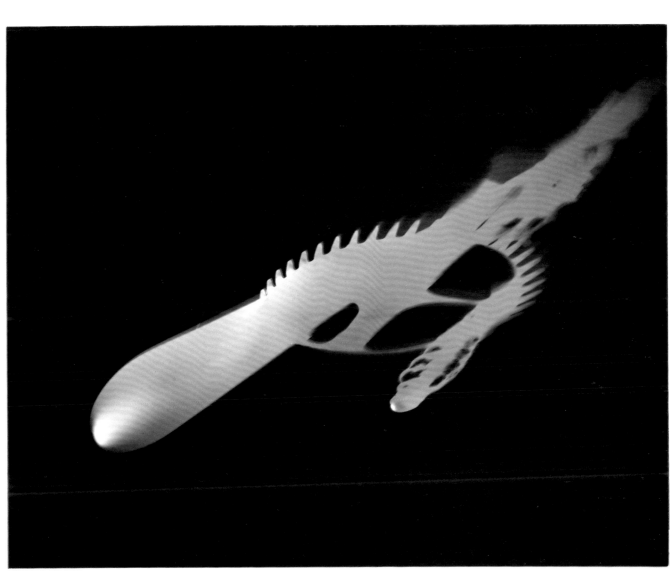

Photogram, n.d., 10" x 8". *Inscribed on back:* Photogram made in the Photo courses of the School of Design in Chicago, 247 East Ontario St. To study the reaction of the light sensitive emulsion a mixer was placed directly on the printing paper and exposed to light without a camera.

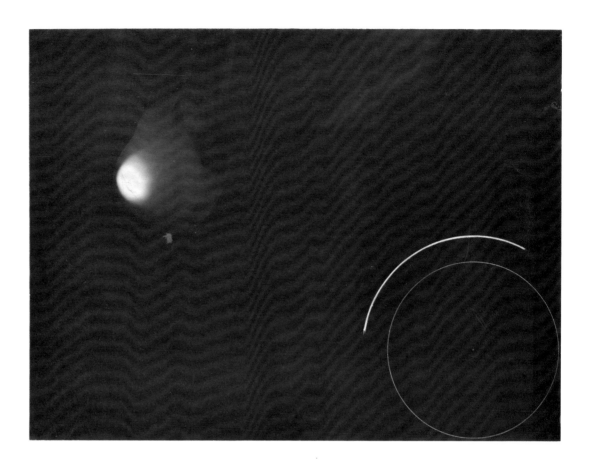

Photogram, n.d., 7″ x 9¾″.

The *photogram* hovers excitingly between abstract geo-
metrical tracery and the echo of objects. In this tension
there often is a peculiar charm. These pictures are taken
without a camera, by the meeting of objects with sensitive
paper. By exposing them a long or a short time, holding
them close or far, letting sharp or subdued artificial light
shine upon them, schemes of luminosity are obtained that
so change the colour, outline and moulding of objects as to
make them lose body and appear but a lustrous strange
world and abstraction.

Franz Roh and Jan Tschichold, editors. *foto-auge; 76 fotos der zeit*, 1929, p. 16.

Photogram, 1925, 9⅜″ x 7¹/₁₆″. *Inscribed on back:* Original, Moholy-Nagy, Fotogramm 1925

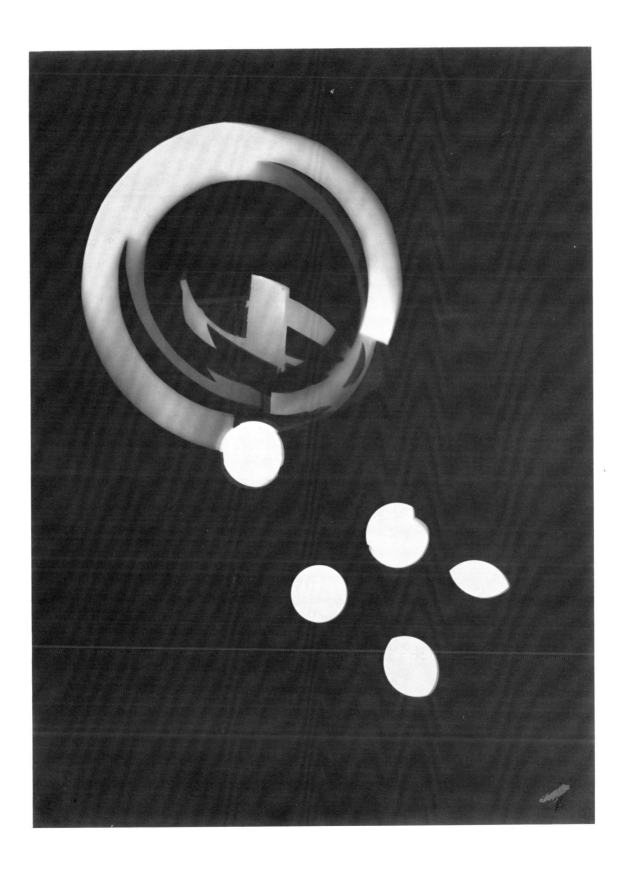

Photograph, n.d., 9⁷⁄₁₆″ x 6⁷⁄₈″.

Photogram, n.d., 10″ x 8″. *Inscribed on back:* L. Moholy-Nagy

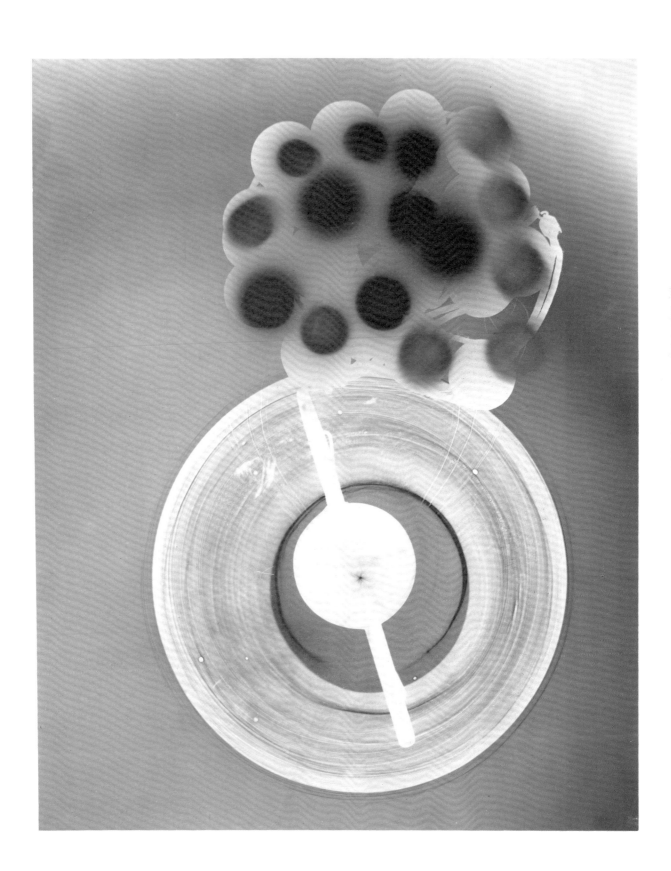

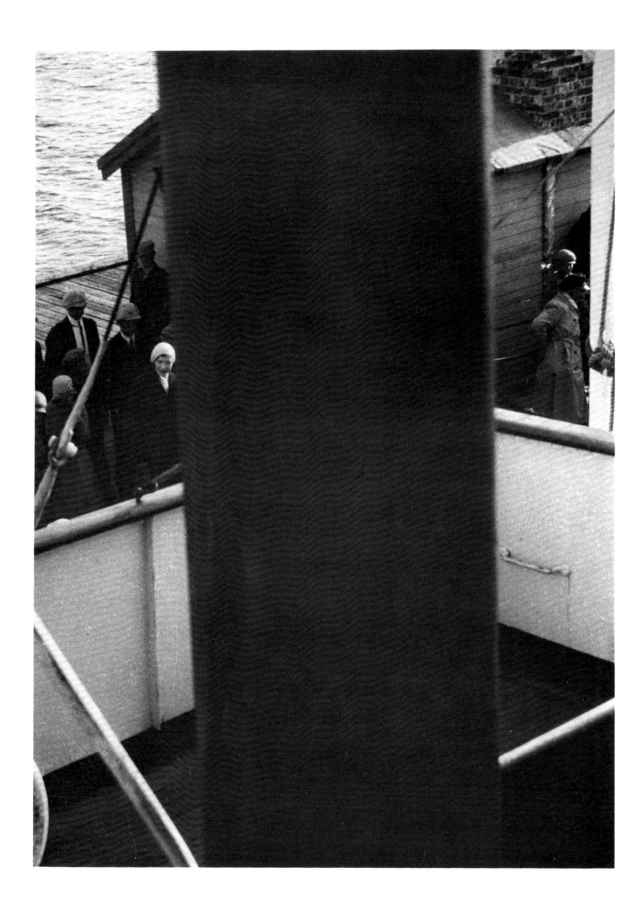

Photograph, n.d., 9⁵/₁₆″ x 6⅞″. *Inscribed on back: am molo erwartet man die fischer ungeduldig,*
[On the mole one waits impatiently for the fishermen], *Finland, Photo, Moholy-Nagy;*
written and crossed out, *der fisch trocknet* [the fish becomes dry]

27. Photogram, May, 1928, 9⅜″ x 7″. *Inscribed and stamped on back:*
 Photogrammetrie, was ein Sonnenstrahl und
 ein bisschen Phantasie aus einem Reibeisen machen konnen [what a sunbeam and a little imagination can make
 out of a grater]; Uhu 5/1928; 9,1 Cm hoch, *Uhu Reibe;* stamped: verlag ullstein Nr. 19087 b; stamped: moholy-nagy

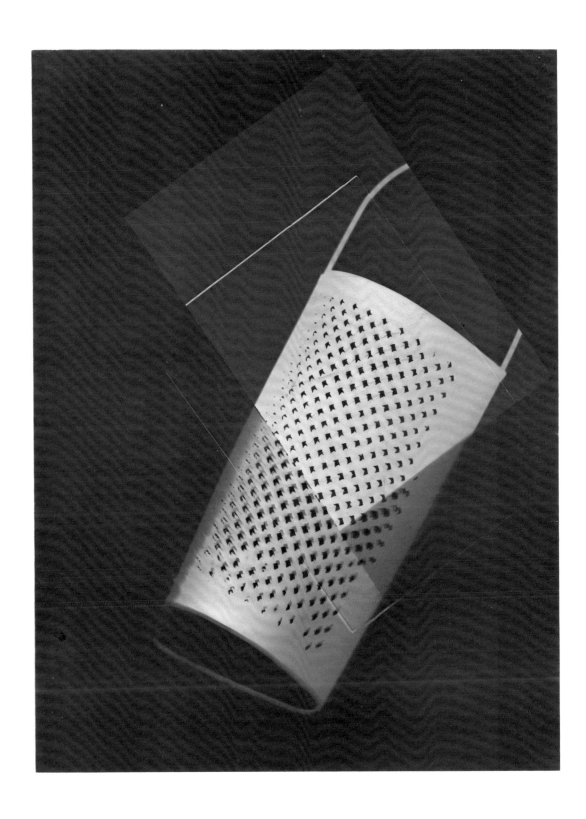

Portrait of Lucia Moholy, Photograph, Modern print from original negative, 1925, 11″ x 8″.

Photograph, n.d., 9¾″ x 7¼″. *Inscribed on back:* L. Moholy-Nagy

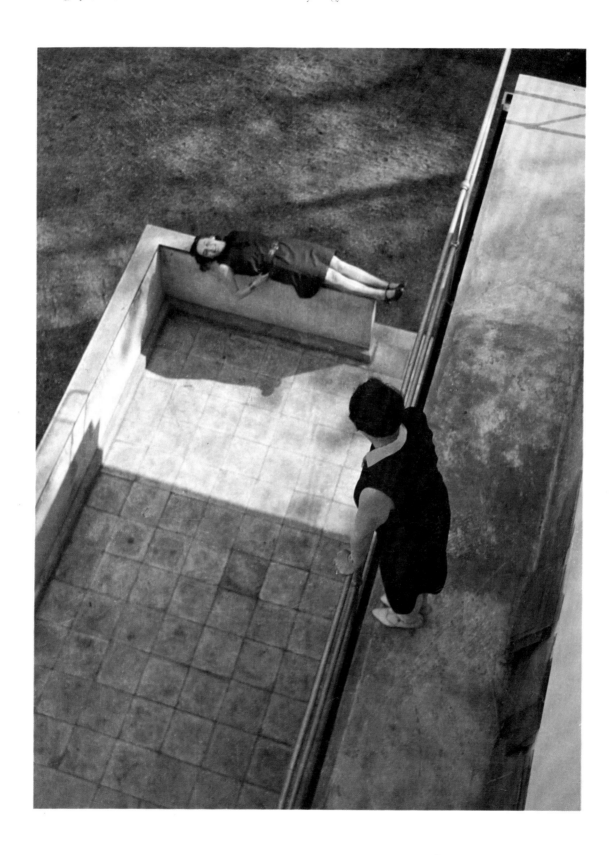

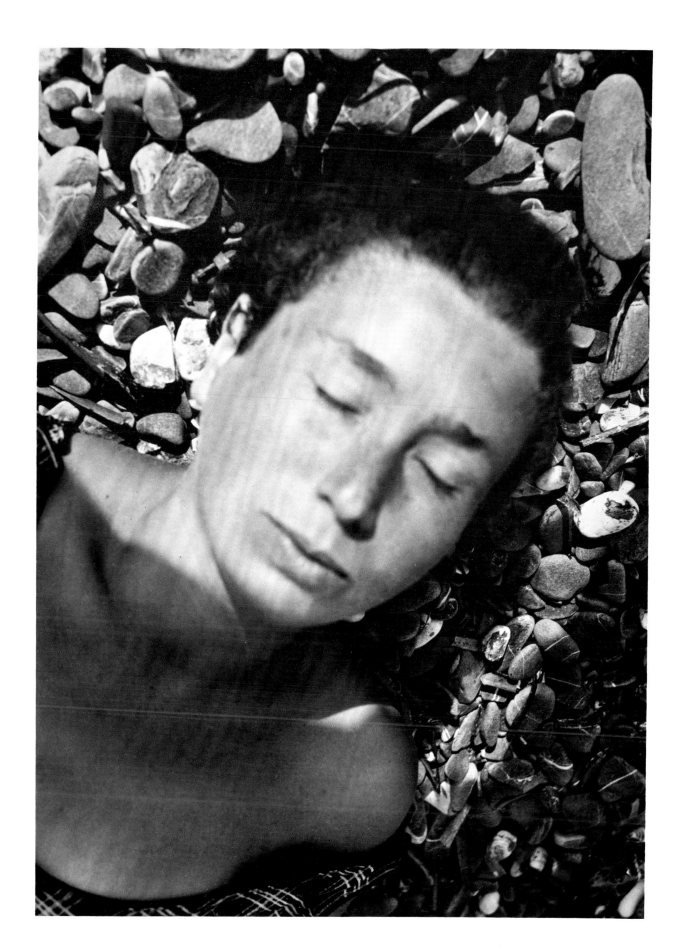

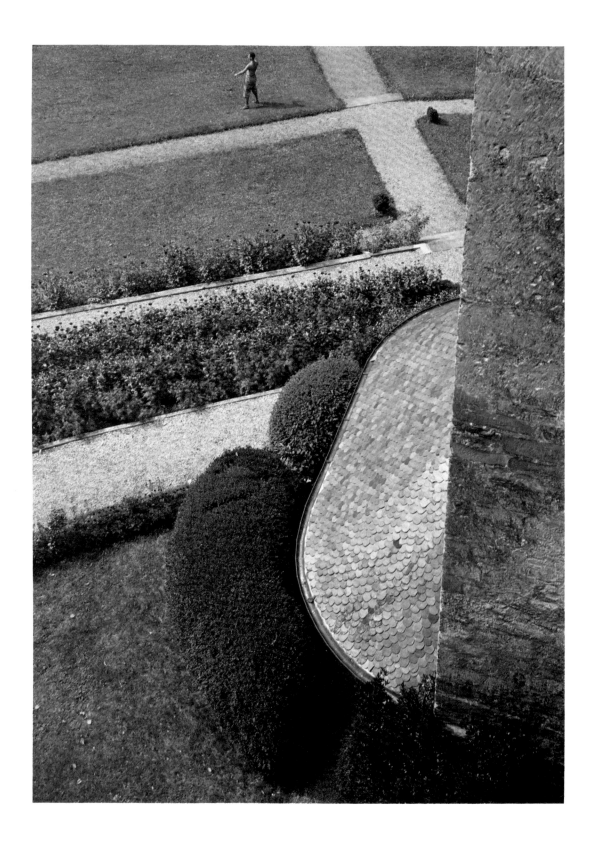

Photograph, Modern print from original negative, n.d., 11″ x 8″.

31.

Both the photographic amateur and the layman, acquiring
through the photogram a deeper understanding of light
and space values, will be inspired to explore the potentialities
of the camera since the photogram teaches that the same
characteristics of gradations and contrasts have to be
applied to camera work too. Good photography with the
camera must enable us to capture the patterned interplay
of light and shadow exactly as in cameraless photography.
Thus photography becomes the translation of a world
saturated with light and color into black, white and
gray gradations.

Laszlo Moholy-Nagy. *Vision in Motion*, (1947), p. 190.

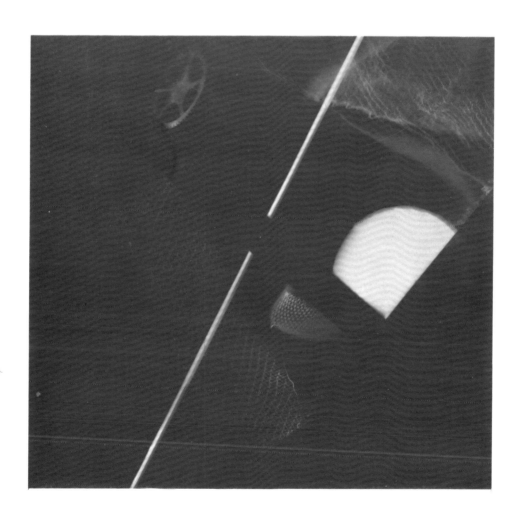

Photogram, n.d., 4¹³⁄₁₆″ x 5″.

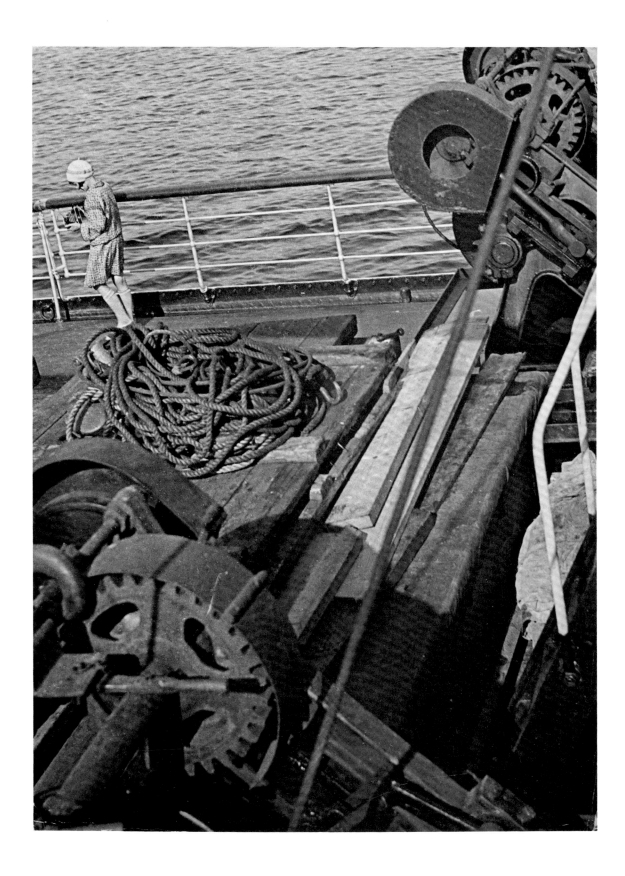

Photograph, n.d., 9½″ x 7¹/₁₆″. *Inscribed and stamped on back:*
fotoreporterin im nordl. eismeer,
[Photoreporter in the north Arctic Sea], Petramo; Berlin stamp

33.

Photograph, n.d., 9″ x 6¾″. *Inscribed on back:*
Eifelturm [Eiffel Tower], Foto Moholy-Nagy

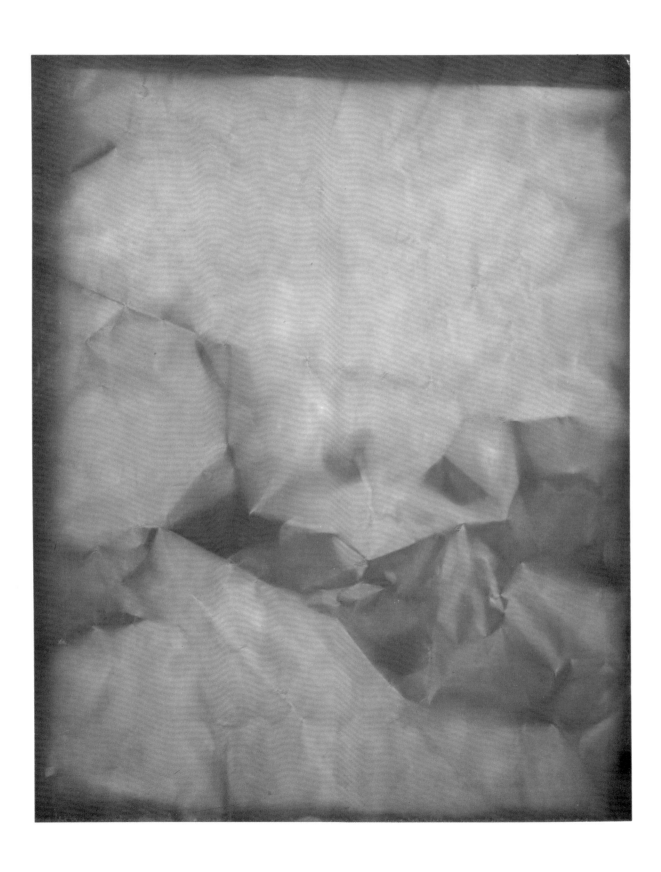

Diagram of Forces, Photogram, n.d., 10" x 7⅞".

Back of *Diagram of Forces. Inscribed:* A light sensitive paper was made wet, squashed and exposed to light. The result is a "diagram of forces" projected on the flat sheet. by L. Moholy-Nagy. (for the cut maker: please print it hard so that you get some white)

Lyon Stadium, Photograph, n.d., 9¼″ x 6⅞″. *Inscribed and stamped on back: Im Stadion von Lyon* [Lyon Stadium],
Foto, Moholy-Nagy; Berlin stamp; foto stamp; stamped: VU Photo No. 2974;
stamped: *Ohne Erlaubnis, Reprodukion verboten* [Without permission, reproduction is forbidden]

37.

Photogram, n.d., 9⅜″ x 7¹/₁₆″.

Photogram, 1943, 8" x 10". Inscribed on back: L. Moholy-Nagy, 43 III B

Despite the obvious fact that the *sensitivity to light*
[emphasis in original] of a chemically prepared surface
(of glass, metal, paper, etc.) was the most important element
in the photographic process, i.e., containing its own laws,
the sensitized surface was always subjected to the demands
of a *camera obscura* adjusted to the traditional laws
of perspective while the full possibilities of this combination
were never sufficiently tested.

L. Moholy-Nagy. "Light: a Medium of Plastic Expression," *Broom*, IV, March 1923, p. 283.

Photogram, Feb. 24, 1939, 7″ x 5″. *Inscribed on back:* Solarized, L. Moholy-Nagy Feb. 24/39

Photogram, n.d., 9⁷⁄₁₆″ x 7¹⁄₁₆″.

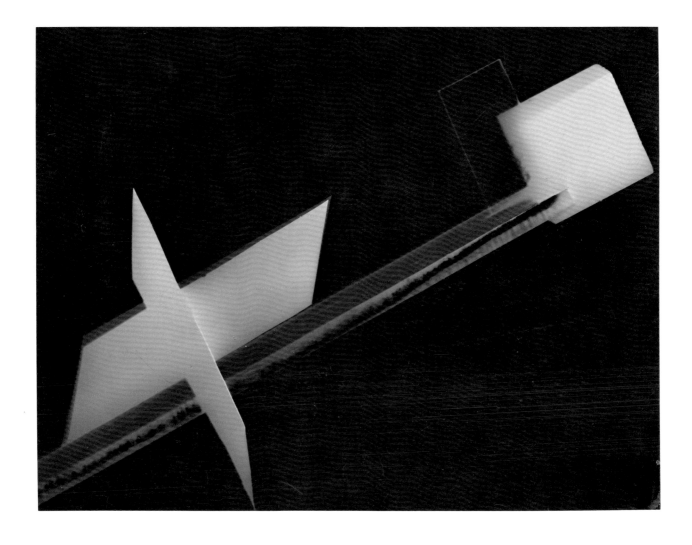

Photogram, 1925, 9⁷⁄₁₆″ x 7⅛″. *Inscribed on back:* fotogram, 1925, Moholy-Nagy, original

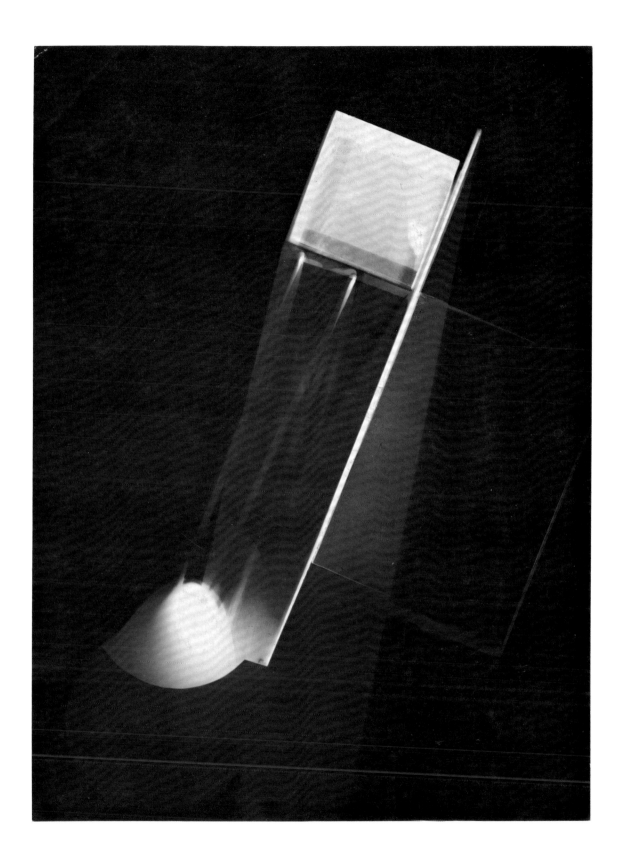

Photogram, 1926, 9⁵/₁₆″ x 7″. *Inscribed and stamped on back: Diessen fleck mit weiss wegretuschieren*
[retouched this spot with white], L. Moholy-Nagy, F 83 (1926), Fotogramm, original, *oben* [top]; photo stamp

The photogram exploits the unique characteristic of the photographic process — the ability to record with delicate fidelity a great range of tonal values. The almost endless range of gradations, subtlest differences in the gray values, belongs to the fundamental properties of photographic quality. The photogram can be called the key to photography because every good photograph must possess the same fine gradations between the white and black extremes as the photogram.

Laszlo Moholy-Nagy. *Vision in Motion*, (1947), p. 188.

Photogram, n.d., 5″ x 7″. *Inscribed on back:* Moholy-Nagy

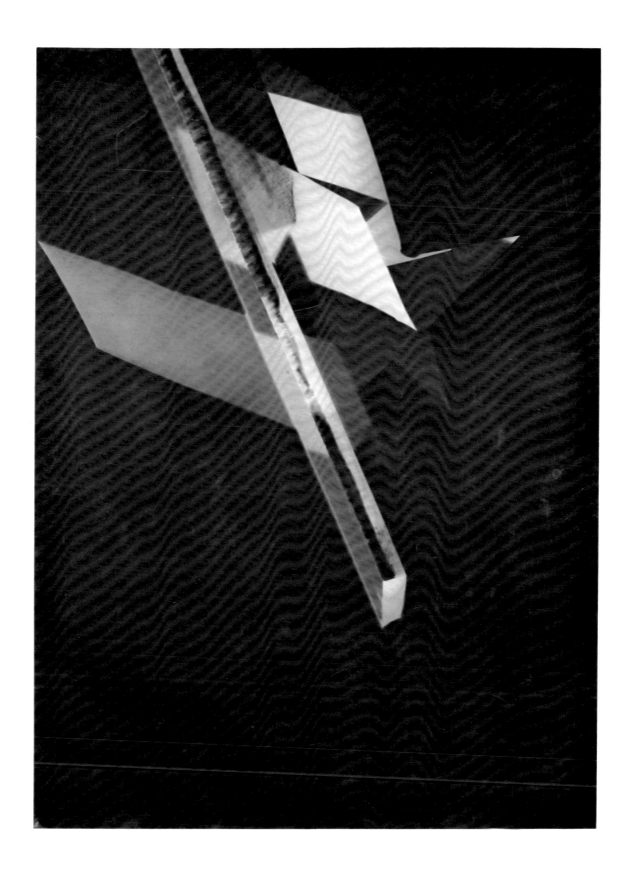

Photogram, n.d., 9⁷/₁₆″ x 7¹/₁₆″.

Photogram, 1922, 3½″ x 5½″. *Inscribed on back:* Moholy-Nagy 1922

Photogram, n.d., 3½″ x 5½″.

47.

Photogram, 1922, 3½" x 5½". *Inscribed and stamped on back:*
Original!!, fotogramm 1922, Berlin stamp

Photogram, 1922, 3½" x 5½". *Inscribed on back:* Moholy-Nagy 1922
Kameraloses [cameraless],
fotogramm 1922, original, Moholy-Nagy

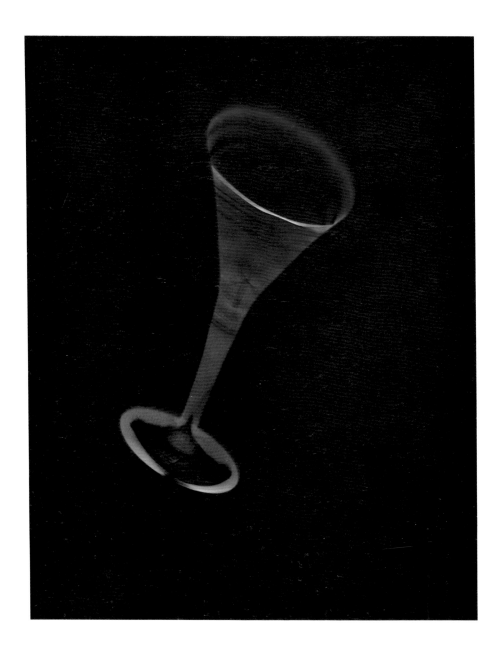

Photogram, n.d., 10″ x 8″. *Inscribed on back*: L. Moholy-Nagy

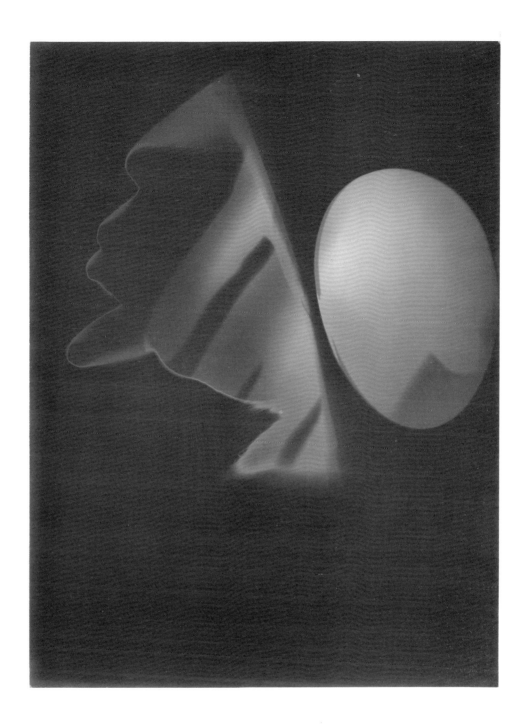

Photogram, n.d., 9⅜″ x 7″.

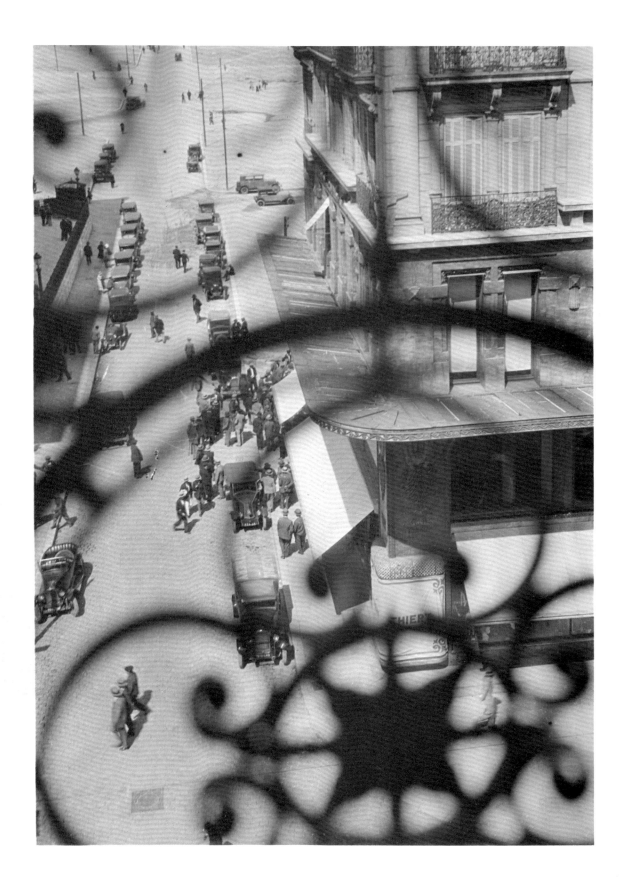

Rue Cannebière, Marseilles, Photograph, n.d., 9¹¹/₁₆″ x 6¹⁵/₁₆″.
Inscribed on back: L. Moholy-Nagy, Rue Cannebière (Marseille, France)

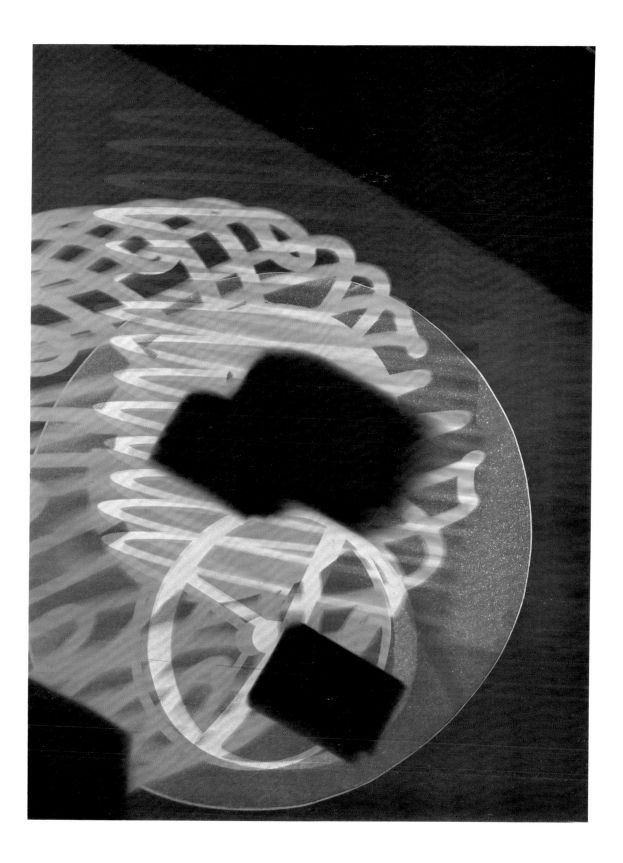

Photogram, n.d., 9⅜″ x 7″.

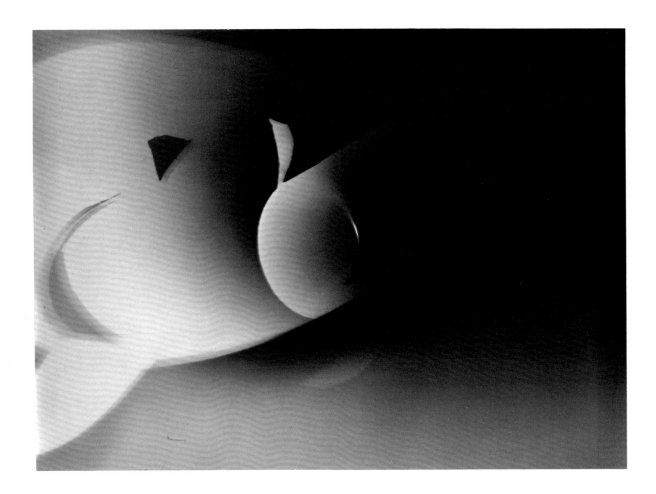

Photogram, 1939, 5″ x 7″. *Inscribed on back:* L. Moholy-Nagy 39

The proper utilization of the plate itself would have
brought to light phenomena imperceptible to the human
eye and made visible only by means of the photographic
apparatus thus perfecting the eye by means of photography.

L. Moholy-Nagy. "Light: a Medium of Plastic Expression," *Broom*, IV, March 1923, p. 283.

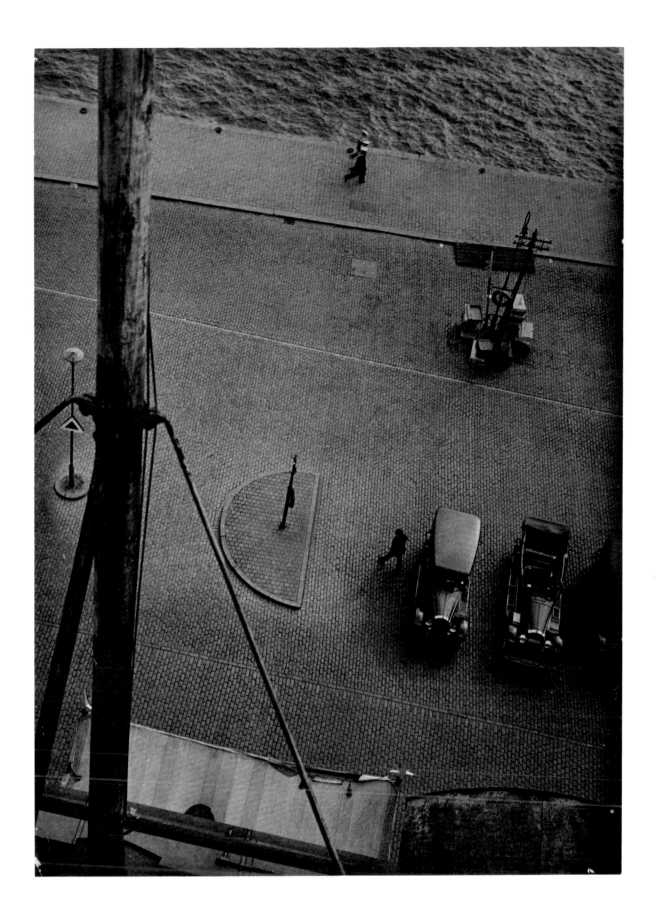

Photograph, n.d., 9½″ x 7″. *Inscribed and stamped on back:* Stockholm; Berlin stamp; photo stamp

Photogram, 1922, 7¹/₁₆″ x 9⁵/₁₆″. *Inscribed on back:* L. Moholy-Nagy, Photogramm, 1922

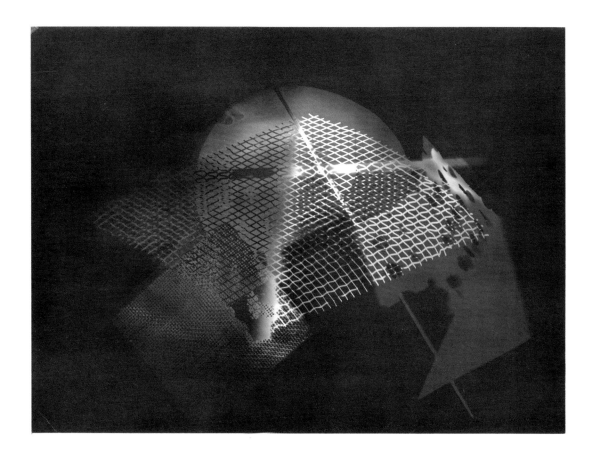

At Coffee. Photograph, n.d., 11¼″ x 8⅛″.
Inscribed and stamped on back: Bei mokka [At coffee];
Berlin stamp; photo stamp

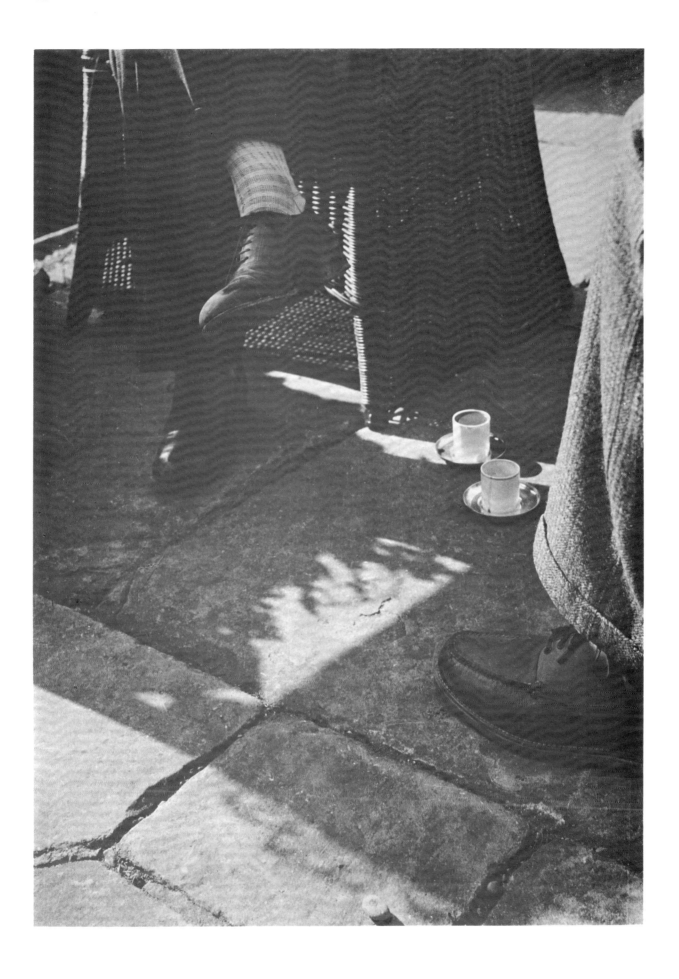

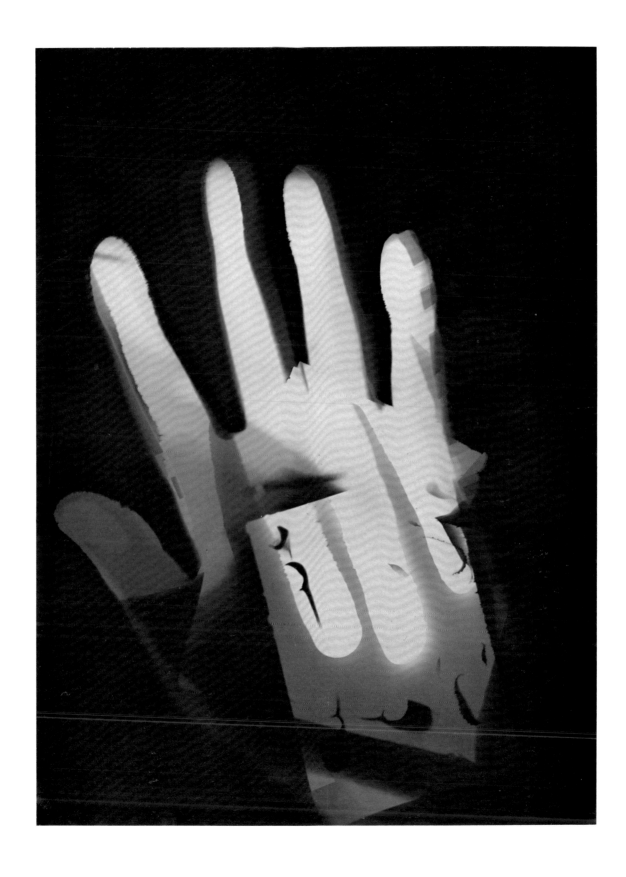

Photogram, 1926, 9⅜″ x 7″. *Inscribed and stamped on back:* Moholy-Nagy, *Kameraloses* [Cameraless], fotografie (1926), 38¾; stamped: Popular Photography, 608 S. Dearborn St., Chicago, Roto Page 31

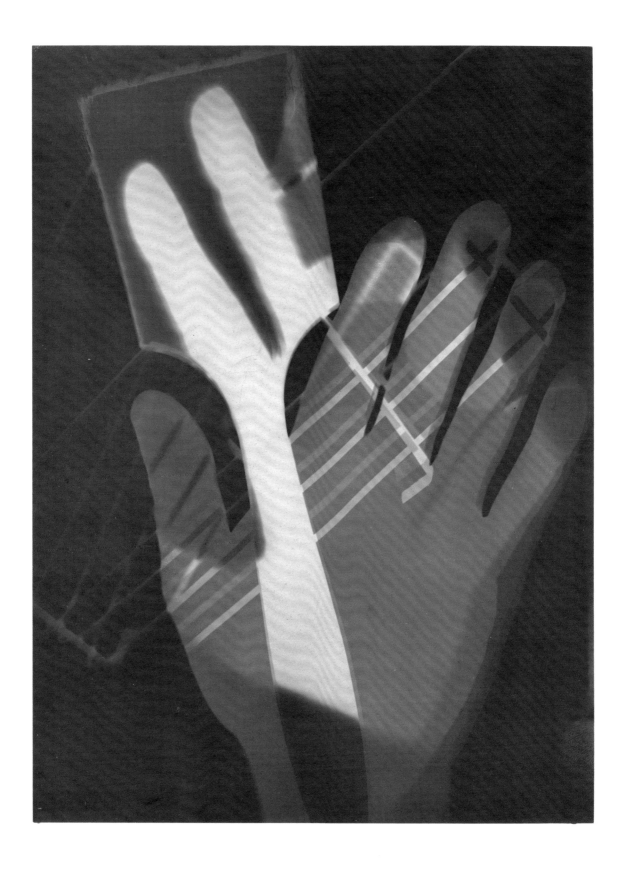

Photogram, n.d., 9⅜″ x 7¹/₁₆″. *Inscribed and stamped on back:* 182, Moholy-Nagy, fotogramm,
Keine Retussche [No retouching], original; photo stamp

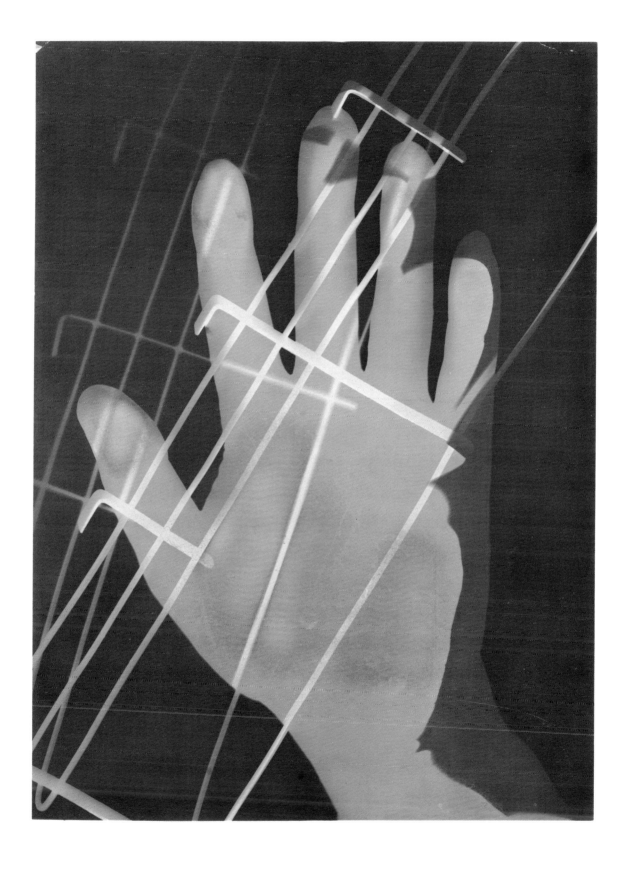

60.

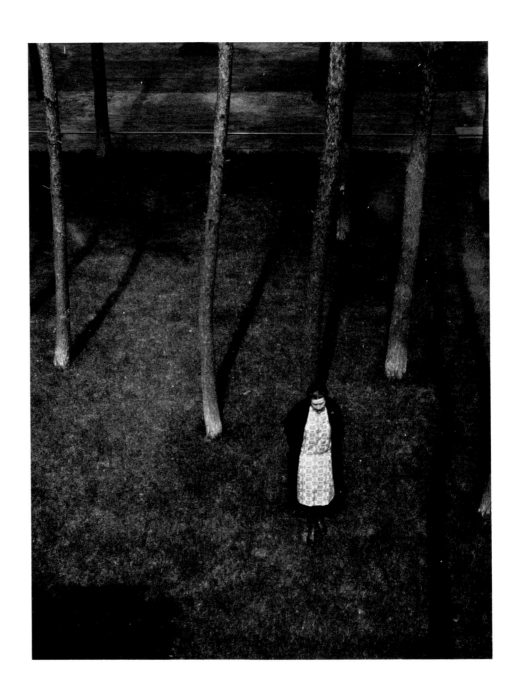

Photograph, Modern print from original negative, n.d., 10½″ x 8¹/₁₆″.

61. ## Selected Bibliography

1A. Books By Laszlo Moholy-Nagy.

1. *Buch Neuer Künstler* (with Lajos Kassák). Vienna: die Aktivistische Zeitschrift "Ma," 1922.
2. *Eton Portrait.* [Photographs by Laszlo Moholy-Nagy, text by Bernard Fergusson.] London: John Miles. (Reprint: London: Muller, 1949.)
3. *The New Vision, 1928, Fourth Revised Edition, and Abstract of an Artist.* New York: George Wittenborn, Inc., 1947. Earlier editions were: *Von Material zu Architektur,* Bauhausbücher 14. Munich: Albert Langen Verlag, 1929. (Facsimile of 1929 edition: Mainz: Florian Kupferberg, 1969.) *The New Vision; from Material to Architecture.* Translated by Daphne M. Hoffman. New York: Brewer, Warren & Putnam, Inc., 1932. *The New Vision; Fundamentals of Design, Painting, Sculpture, Architecture.* New York: W. W. Norton & Company, Inc., 1938. *The New Vision, 1928, Third Revised Edition, and Abstract of an Artist.* New York: Wittenborn and Company, 1946.
4. *Painting, Photography, Film.* Translated by Janet Seligman. Cambridge, Massachusetts: The M.I.T. Press, 1969. The German editions were: *Malerei, Photographie, Film,* Bauhausbücher 8. Munich: Albert Langen Verlag, 1925; *Malerei, Fotografie, Film,* Bauhausbücher 8; 2. Aufl. Munich: Albert Langen Verlag, 1927.
5. *60 Fotos,* edited by Franz Roh, Fototek, volume 1. Berlin: Klinkhardt & Biermann, 1930.
6. *The Street Markets of London.* [Photographs by Laszlo Moholy-Nagy, text by Mary Benedetta.] London: John Miles, 1936. (Reprint: New York: Benjamin Blom, 1972.)
7. *Vision in Motion* Chicago: Paul Theobald and Company, 1947.

1B. Collections of Essays and Articles By and About Laszlo Moholy-Nagy.

8. KOSTELANETZ, RICHARD, editor. *Moholy-Nagy.* Documentary Monographs in Modern Art. New York: Praeger Publishers, 1970.
9. *Telehor, the International Review for New Vision,* 1936. [A quadrilingual magazine published in Brno, Czechoslovakia, of which only one issue appeared, a special issue on Moholy.]

2A. Books Mainly About Laszlo Moholy-Nagy.

10. MOHOLY, LUCIA. *Moholy-Nagy, Marginal Notes; Documentary Ab-*surdities. Krefeld, Germany: Scherpe Verlag, 1972.
11. MOHOLY-NAGY, SIBYL. *Moholy-Nagy; Experiment in Totality.* New York: Harper and Brothers, 1950. (2nd edition, Cambridge, Massachusetts: The M.I.T. Press, 1969.)
12. WEITEMEIR, HANNAH. *Licht-Visionen; ein Experiment von Moholy-Nagy.* Berlin: Bauhaus-Archiv. 1972.

2B. Books Partly About Laszlo Moholy-Nagy.

13. BANHAM, REYNER. *Theory and Design in the First Machine Age,* 2nd. edition. New York: Frederick A. Praeger, 1967.
14. NAYLOR, GILLIAN. *The Bauhaus.* New York: E. P. Dutton and Co., Inc., 1968.
15. WINGLER, HANS M. *The Bauhaus; Weimar, Dessau, Berlin, Chicago.* Cambridge, Massachusetts: The M.I.T. Press, 1969.

3. Essays and Articles By Laszlo Moholy-Nagy.

16. "Design Potentialities," Paul Zucker, editor, *New Architecture and City Planning; a Symposium.* New York: Philosophical Library, 1944, pp. 675-687. (reprinted in: Richard Kostelanetz, editor, *Moholy-Nagy.* Documentary Monographs in Modern Art. New York, Praeger Publishers, 1970, pp. 81-90.)
17. "Education in Various Media for the Designer," National Society for the Study of Education, *The Fortieth Yearbook; Art in American Life and Education.* Bloomington, Illinois: Public School Publishing Company, 1941, pp. 652-657.
18. "Fotografie Ist Lichtgestaltung," *Bauhaus; Zeitschrift für Gestaltung,* II/1, 1928, pp. 2-9.
19. "Lichtrequist einer elektrischen Bühne (Lichtmodulator)," *Die Form* V/11-12, 1930, pp. 297-299.
20. "Light; a Medium of Plastic Expression." *Broom; an International Magazine of the Arts,* IV/4, March, 1923, pp. 283-[284] (photograms by Laszlo Moholy-Nagy appeared on pp. facing pp. 224, 225, 240 and 241). Reprinted: Nathan Lyons, editor, *Photographers on Photography.* Englewood Cliffs, New Jersey: Prentice-Hall, 1966, pp. 72-73.
21. "New Approach to Fundamentals of Design," *More Business,* III/11, November, 1938, pp. 4-6. (This was part of a special issued on the New Bauhaus, edited by Laszlo Moholy-Nagy and Gyorgy Kepes; see front cover and pp. 4-[18]).
22. "On Art and the Photograph," *The Technology Review,* XLVII/9, June, 1945, pp. 491-4, 518, 520 and 522.

23. "Painting with Light — a New Medium of Expression," *The Penrose Annual; Review of the Graphic Arts,* XLI, pp. 25-31. London: Lund Humphries & Co., Ltd., 1939.
24. "Paths to the Unleashed Colour Camera," *The Penrose Annual; Review of the Graphic Arts,* XXXIX, pp. 25-28 and illustrations facing pp. 28 and 29. London: Lund Humphries & Co., Ltd., 1937.
25. "Photography," Dagobert D. Runes and Harry G. Schrickel, editors, *Encyclopedia of the Arts.* New York: Philosophical Library, 1946, pp. 749-755.
26. "Photography," Golden Gate International Exposition, San Francisco, *A Pageant of Photography.* Introduction by Ansel Adams. San Francisco: Crocker-Union, 1940, pp. 22-23.
27. "Photography in the Study of Design," *American Annual of Photography 1945,* LIX, pp. 158-164. Boston: 1944.
28. "Produktion-Reproduktion," *De Stijl,* V/7, Juli, 1922, pp. 98-100.
29. "Space-time and the Photographer," *American Annual of Photography 1943,* LVII. Boston: 1942, pp. 158-164.
30. "Why Bauhaus Education?", *Shelter; a Correlating Medium for Housing Progress,* III/1, March, 1938, pp. [6]-21.
31. "Zeitgemässe Typographie — Ziele, Praxis, Kritik," *Gutenberg Festschrift zur Feier des 25 Iaehrigen Bestehens des Gutenbergmuseums in Mainz.* Mainz: Verlag der Gutenberg-Gesellschaft, 1925, pp. 307-317.

4. Essays and Articles About Laszlo Moholy-Nagy.

32. BRUNS, RENEE. "L. Moholy-Nagy; a Portfolio of Images Never Before Published by a Master Who Influenced Modern Design," *Popular Photography,* LXXV/2, August, 1974, pp. 88-93, 141.
33. BULLIET, CLARENCE JOSEPH. "Around the Galleries: of Bauhaus and the New Mousetrap," *The Chicago Daily News,* July 9, 1938, p. 13.
34. HARRIS, RUTH GREEN. "The New Bauhaus: a Program for Art Education," *The New York Times,* Sunday, May 29, 1938, part 10, p. 7.
35. KÁLLAI, ERNST. "Ladislaus Moholy-Nagy," *Jahrbuch der Jungen Kunst.* Leipzig: Klinkhardt & Biermann, 1924, pp. 181-[189].
36. KEPES, GYORGY. "Laszlo Moholy-Nagy: the Bauhaus Tradition," *Print,* XXIII/1, January-February, 1969, pp. 35-39.
37. KOPPE, RICHARD. "Laszlo Moholy-Nagy and His Visions," *Art International,* XIII/10, Christmas, 1969, pp. 43-46.

62. Photogram, 1925, 9¾″ x 7″. *Inscribed and stamped on back:* Moholy-Nagy, Fotogramm (1925), *kameraloses* [cameraless]; written and crossed out: *ich bitte das foto eiligst zuruck, dessau, . . . uhnauer allee 2* [Please bring the photo back to Dessau . . .] 4367/II; stamped: moholy-nagy

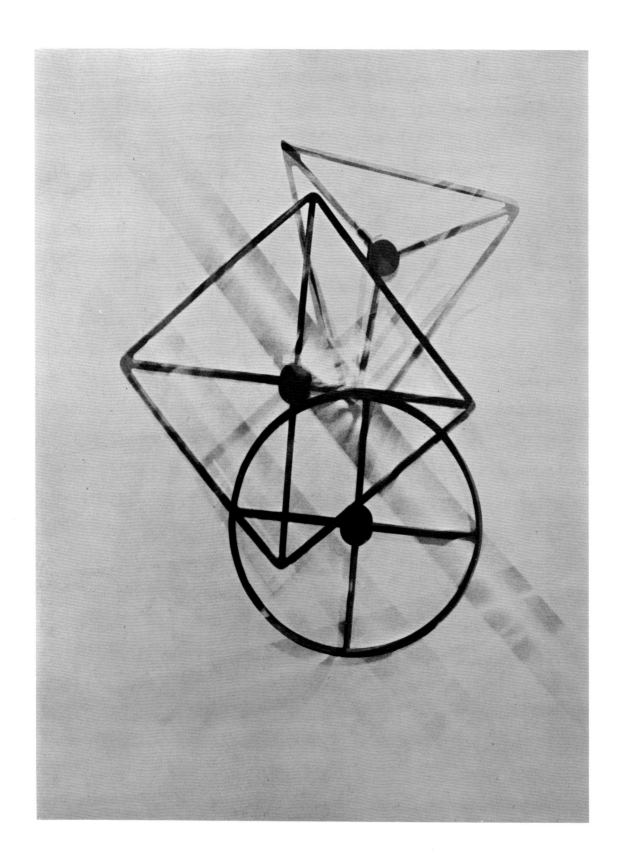

38. KOSTELANETZ, RICHARD. "Moholy-Nagy Exhibition at the Museum of Contemporary Art, Chicago, May 31-July 13." *Artscanada*, XXVI/5, October 1969, pp. 47-48.

39. MÁTYÁS, PÉTER. "Moholy-Nagy," *Ma; Aktivista Folyóirat*, VI/9, September, 1921, text on p. 119, illustrations on front cover and pp. 121, 123, 125-130.

40. MOHOLY-NAGY, SIYBL. "Moholy-Nagy: Photographer," *American Photography*, VL/1, January 1951, pp. 40-44.

41. NEWHALL, BEAUMONT. "The Photography of Moholy-Nagy," *The Kenyon Review*, III/1, Summer, 1941, pp. 344-351.

42. PÉTER, LÁSZLÓ, "The Young Years of Moholy-Nagy," *The New Hungarian Quarterly*, XIII/46, pp. [62]-72, and illustrations on 2 unnumbered leaves following p. 64.

43. REICHARDT, JASIA. "Moholy-Nagy and Light Art as an Art of the Future," *Studio International*, CLXXIV/894, November, 1967, p. 184.

44. ROSE, BARBARA. "Kinetic Solutions to Pictorial Problems: the Films of Man Ray and Moholy-Nagy," *Artforum*, X/1 September, 1971, pp. 68-73.

5A. Exhibition Catalogs of One-Person Showings of Laszlo Moholy-Nagy.

45. ART INSTITUTE OF CHICAGO. *L. Moholy-Nagy; an Exhibition Sponsored by the Society for Contemporary American Art, Sept. 18 to Oct. 26, 1947.* Chicago: The Art Institute of Chicago, 1947.

46. BAUHAUS-ARCHIV, BERLIN. *Laszlo Moholy-Nagy; Ausschnitte aus einem Lebenswerk, Bildnerische Arbeiten, Fotos, Unterricht. Ausstellung von Leihgaben und Sammlungsbeständen des Bauhaus-Archivs, Berlin . . . vom 18. Februar bis zum 30, Marz, 1972.* Berlin: Bauhaus-Archiv, 1972.

47. BAUHAUS-ARCHIV, BERLIN. *Laszlo Moholy-Nagy; farbige Zeichnungen, 1941-1946, 18. Februar-30. März, 1972.* Berlin: Bauhaus-Archiv, 1972.

48. BAUHAUS-ARCHIV, BERLIN. *Laszlo Moholy-Nagy; Fotografien, Fotogramme, Fotoplastiken, 18. Februar-30. März, 1972.* Berlin: Bauhaus-Archiv, 1972.

49. GALERIE KLIHM, MUNICH. *Moholy-Nagy; farbige Zeichnungen 1941-1946, 26. 1., 1971 bis 25. 5., 1971.* Munich: Galerie Klihm, 1971.

50. INSTITUTE OF DESIGN, CHICAGO. *Moholy; Paintings, Sculptures, Photograms and Photographs by L. Moholy-Nagy.* Chicago: Institute of Design, 1946.

51. MUSEUM OF CONTEMPORARY ART, CHICAGO. *Laszlo Moholy-Nagy; an Exhibition Organized by the Museum of Contemporary Art and the Solomon R. Guggenheim Museum.* [Also shown at the Santa Barbara Museum of Art, the University Art Museum at the University of California, Berkeley, and the Seattle Art Museum.] Chicago: Museum of Contemporary Art, 1969.

52. NEW LONDON GALLERY. *Moholy-Nagy; May-June, 1961.* London: New London Gallery, 1961.

53. SOLOMON R. GUGGENHEIM FOUNDATION. *In Memoriam Laszlo Moholy-Nagy; the Solomon R. Guggenheim Foundation Presents a Survey of the Artist's Paintings and Plastics at the Museum of Non-Objective Painting . . . May 15th to July 10th, 1947.* New York: Solomon R. Guggenheim Foundation, 1947.

54. STEDELIJK VAN ABBEMUSEUM, EINDHOVEN. *Moholy-Nagy; Stedelijk van Abbemuseum, Eindhoven, 20 Januari-5 Maart, 1967; Haags Gemeentemuseum, 14 Maart-20 April; Von der Heydtmuseum, Wuppertal, 13 Mei-18 Juni.* Eindhoven, Holland: Stedelijk van Abbemuseum, 1967.

55. DER STURM. *Hundertfünfte Ausstellung, Februar, 1922; Moholy-Nagy, Peri [und] Gesamtschau des Sturm.* Berlin: Der Sturm, 1922.

5B. Exhibition Catalogs of Group Showings Which Included Work By Laszlo Moholy-Nagy.

56. *Bauhaus, 50 Years; German Exhibition . . . Organized by the Württembergischer Kunstverein . . . with the Bauhaus-Archiv, Darmstadt [shown at] Illinois Institute of Technology, Crown Hall . . . August 25th [to] September 26th, 1969.* Chicago: Illinois Institute of Technology, 1969.

57. BAYER, HERBERT, GROPIUS, WALTER AND GROPIUS, ISE, EDITORS. *Bauhaus 1919-1928.* New York: The Museum of Modern Art, 1938. (Reprint of 1938 edition: New York: Arno Press, 1974.) New edition: Boston: Charles T. Branford Company, 1959.

58. SOCIÉTÉ DES ARTISTES DÉCORATEURS. *Catalogue du 20e Salon du 15 Mai au 13 Juilliet, 1930.* Paris: Grand Palais des Champs-Elysées, Rue Jean-Goujon, 1930.

6. Books About Photography.

59. COKE, VAN DEREN. *The Painter and the Photographer.* Albuquerque: University of New Mexico Press, 1964. (2nd ed., 1970).

60. GERNSHEIM, HELMUT. *Creative Photography: Aesthetic Trends 1839-1960.* Boston: Boston Book and Art Shop, 1962.

61. KAHMEN, VOLKER. *Fotografie als Kunst.* Tubingen: Verlag Ernst Wasmuth, 1973.

62. KRAMER, HILTON. "Three Who Photographed the Twenties and Thirties," *New York Times*, March 3, 1974.

63. MOHOLY, LUCIA. *A Hundred Years of Photography, 1839-1939.* Harmondsworth, Middlesex: Penguin Books, Limited, 1939.

64. NEWHALL, BEAUMONT. *A History of Photography.* Revised edition. New York: The Museum of Modern Art, 1964.

65. PALAZZOLI, DANIELA and CARLUCCIO, LUIGI. *Combattimento Per Un'Immagine, Fotografie e Pittori.* Turin: Galleria Civica d'arte moderna, 1973.

66. ROH, FRANZ, and TSCHICHOLD, JAN., Editors, *Photo-Eye/Foto-Auge: 76 Fotos der Zeit.* (Unveranderter Nachdruck, c. 1929 edition). Tubingen, Germany: Ernst Wasmuth, 1973. English edition: *Photo-Eye: 76 Photos of the Period.* New York: Arno Press, 1973.

67. SCHARF, AARON. *Creative Photography.* New York: Reinhold, 1965.

68. _____. *Art and Photography.* London: Allen Lane, The Penguin Press, 1968.

69. SZARKOWSKI, JOHN. *Looking at Photographs.* Greenwich, Conn.: New York Graphic Society, 1973.

Design: R. Overby, Los Angeles.

Typesetting: Ad Compositors, Los Angeles.

Set in Caledonia and Franklin Gothic.

Paperstock: Warrens' 100 lb. Cameo dull text and cover.

Halftones: Lionel Lindsay, Los Angeles.

Printing: Tom Jones, Los Angeles.

Bindery: Dependable, Los Angeles.

3,000 copies of this catalogue were reproduced at the occasion of the exhibition.

Photogram, 1925, 9⅜″ x 7″. *Inscribed on back:* Moholy-Nagy, *kameraloses* [cameraless], fotogramm (1925)

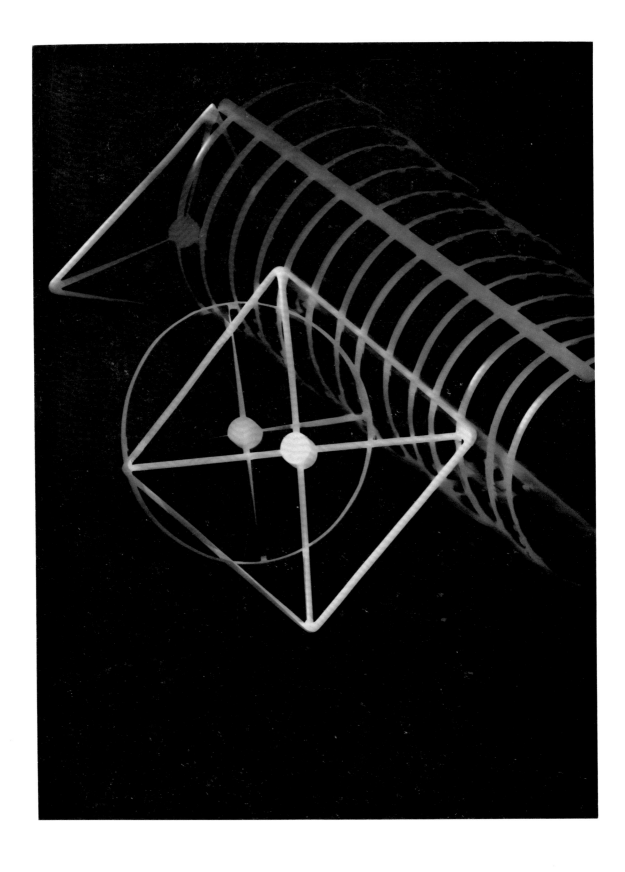